HULL COLLEGE

Body Art

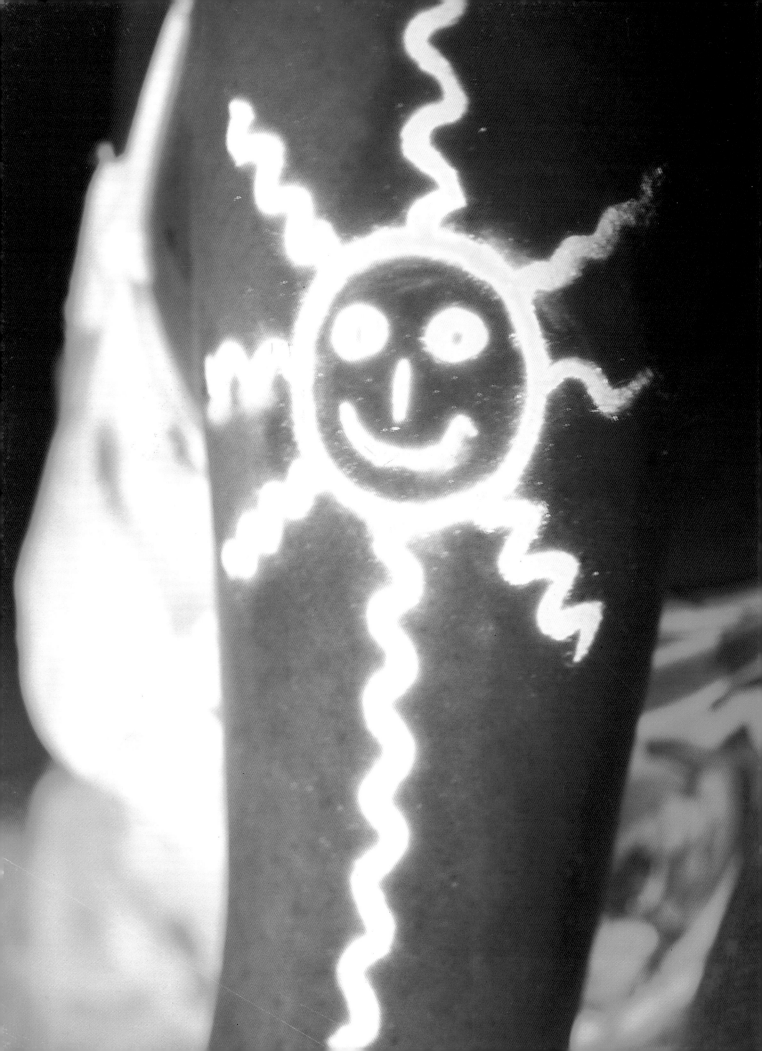

Body Art

Kym Menzies

Oceana

An Oceana Book

Published by
Oceana Books
6 Blundell Street
London N7 9BH

ISBN 1–86160–289–8

QUMBDAT

Project Management/Photography Direction:
Rebecca Kingsley & Joyce Bentley
Writer/Editor: Graham Van As
Design: Martin Laurie at Axis Design
Photographer: Celia Peterson

Manufactured in Singapore by Eray Scan Pte Ltd
Printed in Singapore by Star Standard Industries (Pte.) Ltd

Contents

Introduction

What is body art? Creating your own look is at the heart of body art. Expressing your personality through your choice of clothes, hair design and make-up makes a statement about who you are and what you like. Your choice of hair design and make-up; essentially your body decoration, tells a story or creates a mystery surrounding you, the wearer.

What is fashion?

One only has to open any fashion magazine to recognise that almost anything goes. After all, what is fashion? Fashion is nothing more than a creative idea that is realised by an enterprising and imaginative soul and is later copied by others who like the look. Hair and beauty techniques are constantly changing and breaking new ground in creating new and exciting images.

About this book

The projects outlined in this book cover a wide range of body art techniques and include chapters on body painting, make-up, hair decorating, nail art and the many uses of henna. It also has pages dedicated to guidelines in skin care, hair care and nail care. We have included hair and make-up suggestions for a natural everyday look as well as ideas for body decoration appropriate for partying or just having some fun. Whether you wish to dip in for inspiration or follow one of the specific projects through to completion, this book will help you discover the joy of body art.

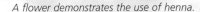

A flower demonstrates the use of henna.

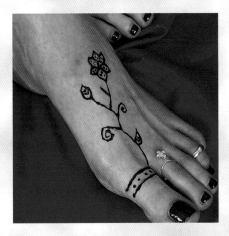

What you will need

You will need a few basic make-up products such as concealer, powder, lipstick, lipgloss, foundation, blusher, eyebrow pencil, mascara and a few brushes for application. Each of the step-by-step projects in this book clearly list what you will need. We will be covering creative suggestions using stencils, tattoos, Kum Kum and application of bindhis and beads, which you will have to buy as you go along; however, many of these products are reusable and inexpensive.

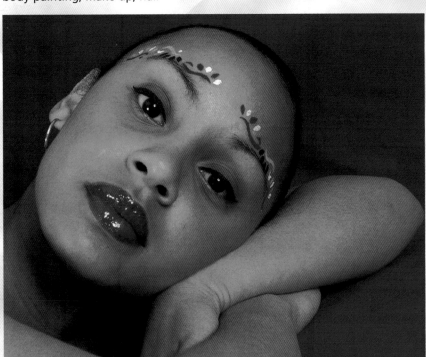

Kum Kum is used to create a forehead design.

Accessories

The expression 'anything goes' comes to mind. Accessories are fun; keep your eyes open for anything and everything which is attractive that you can use to adorn your look. Feathers wound into the hair or beads applied to the skin can look wonderful and again help to define your style. Now more than ever, with fabulous products on the market, the only limitation to expressing your creativity is your imagination.

Spiky hair for a glamourous look.

Body art around the world

Self-expression through body adornment is as old as mankind. Throughout history people have reflected their rich and diverse cultural backgrounds in the way they look. Body art allows people to transform themselves to the image that best represents the way they feel.

From all corners of the earth come distinctive and original designs in body art which reflect the people and the way of life of those who wear them. In parts of Africa women are thought attractive if their necks are long and slender, and so from an early age rings are fitted around their necks pushing their shoulders down and stretching their necks. In other parts of the world there are more extreme fashion statements, such as the Maori people of New Zealand who cut long grooves into their faces to create swirling patterns and then rub black dyes into the scars. In Asian cultures henna powder is mixed into a paste and used to decorate the hands and feet of women with beautiful patterns, especially if there is going to be a wedding. Decades ago in China men and women decorated and wore their nails to incredible lengths as a visible sign of social status. In Indonesia nail art has been an art form for hundreds of years and used within their rich dance culture.

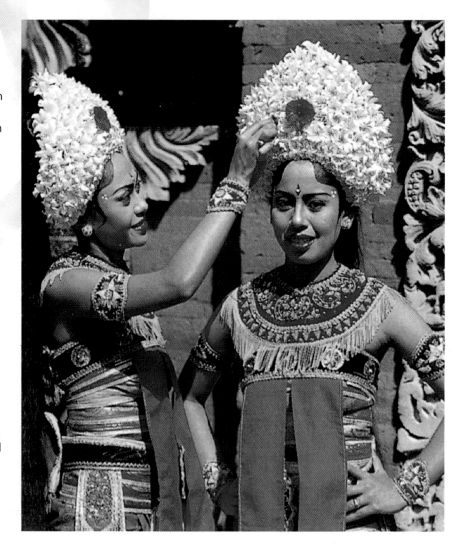

Ornate body art and headdresses are an essential part of Balinese culture.

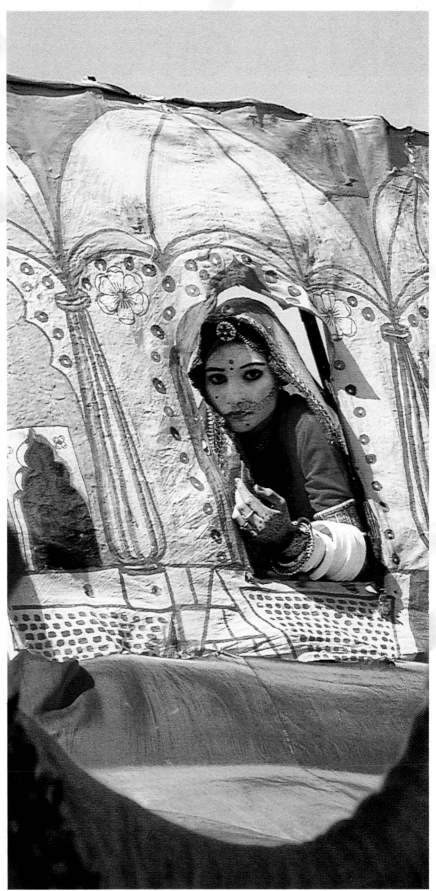

A Rajasthani woman takes part in an Indian festival.

Western body art is often as much a statement of the wearer's personality as it is a decorative art. The 1950s gave birth to the mods and rockers - scooters, teddy boys, big hair, and crêpe-soled shoes - whilst the girls sported bobby socks and wool cardigans in pastel shades. The 60s brought us Flower Power and the psychedelic colours of the age. Free love flowed and was represented by sitars, kaftans, sandals, bracelets and long hair, and the theme of nature dominated the dress code of the times.

The late 70s gave us punk rock: an attempt to shock the establishment and to challenge conservative views of dress sense. Safety pins became an overnight fashion accessory, and if your hair wasn't pink and sculpted with sugar paste then you were as boring as your parents generation (who incidentally were the ones into quiffs and winkle pickers a couple of decades before). Body art continues to evolve, incorporating styles and fashions from around the world.

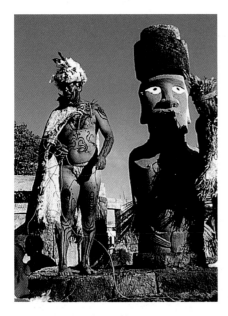

Body art is used in an Easter Island festival in the Pacific.

Skin care

The skin is a living breathing tissue that is designed to fulfil three purposes: to be a protective barrier, to help control heat loss and lastly to perform a vital role as a sensory organ through touch. But there is no reason why it can't look fabulous too.

For most of us good skin is a direct result of a good diet and sensible skin care. There's no substitute for fresh fruit and vegetables, which contain the nutritional elements essential for a healthy complexion. However, a good skin-care routine is also important, particularly for your face which is rarely covered and therefore exposed daily to the sun and wind.

Skin Types

Before you start on your skin-care routine it is important to know your skin type so that you can use the correct sort of products. Skin types tend to fall into one of four categories: normal, dry (prone to flaky skin), oily (shiny and prone to excessive blackheads) or combination (usually an oily forehead, nose and chin with dry cheeks). If you are unsure, try asking one of the trained beauticians at the make-up counter of your local department store to help you. Before you use any new product, always test it on a small patch of skin first in case of an unpleasant reaction.

Cleansing routine

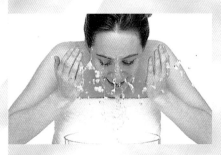

1 Tie your hair back from your face. Use warm water to wash your face.

2 Apply a little cleanser to your skin and lather well. Massage in using fingertips.

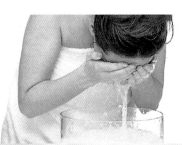

3 Rinse your face thoroughly with fresh warm water.

4 Using a towel to keep in the steam, place your face over a bowl of hot water for a few minutes. Do not use boiling water, hot water is sufficient to open the pores.

5 Use a toner to remove the last traces of cleanser and refresh the skin. Follow this with a good moisturiser.

Cleansing

To begin your routine, there is very little substitute for regular soap and water or a good cleansing lotion. If your skin is sensitive try to avoid heavily scented or coloured products as both the ingredients of perfume and colour may irritate your skin. A perfume-free and gentle soap is the safest. If you want to be as kind to your skin as possible then use baby products. For deep cleansing of your face you can warm the face and gently open the pores with steam by filling a bowl with hot water and placing your face over the bowl with a towel covering your head to prevent the steam escaping. A few minutes should be long enough to warm the skin. Be careful as too much cleansing will over stimulate the skin – using a facial mask or gentle exfoliator once a week is usually enough.

Astringents and Moisturisers

Astringents (often known as skin tonics or toners) help to tighten the skin and leave the face feeling fresh and clean. Apply these to your skin after cleansing, or for a cheaper alternative, simply splash your face with cool or cold water. Follow this with a good moisturiser which will reduce the damage done by dirt and the elements and help to maintain your skin in a healthy state. Massage the moisturiser into the skin on a regular basis, morning and night. Getting into good habits now will keep your skin looking young and radiant for years ahead.

Exfoliation

Exfoliate your skin once a week to help remove dead epidermal skin cells. Use a body brush or a loofah on your body, brushing your skin in circular movements. But for the more delicate skin on your face and neck buy a gentle face scrub. These contain granules, such as finely ground peach stone which act as a mild abrasive to lift off unwanted dead skin. Above all, be gentle as too much exfoliation can result in wearing down the protective epidermal skin layer.

Skin Problems

Some skin problems cannot be cured by even the best of skin-care regimes. One of the most common skin problems in young adults is acne. It usually disappears, as you grow older, but can be very painful and embarrassing while you have it. Exfoliating and using a good cleansing agent will help to prevent the blackheads that can lead to acne, but if you have the problem severely, your doctor may be able to prescribe you with medication. Any other rashes or irritations of the skin should always be seen by a medical practitioner.

In addition to diet and cleansing, lifestyle factors, such as the amount of sleep you get, can influence the health of your skin.

Hair care

The route to healthy-looking hair is a diet of fresh fruit and vegetables that provides the essential vitamins and minerals to help hair growth. Your hair is continually renewing itself. It grows at a rate of 1.5 cm ($\frac{1}{2}$ inch) a month. A hair strand has a lifespan of four to five years, so it's worth looking after your hair because it's on your head for a long time.

Hair condition

It is important to get to know your hair type so that you can treat it with the right products. Hair types tend to fall into three categories: Normal - looks shiny and has body and strength. Dry - looks dull and lifeless and tends to be flyaway and fluffy. Oily - looks greasy very quickly after washing and becomes dark and matted at the roots. Knowing your hair type will help you to decide which products are best for your hair. If in doubt ask a beauty consultant or your hairdresser.

Shampooing

Shampooing is a vital stage in good hair care. Using a shampoo on your hair and scalp will not only keep it looking healthy but will leave it in the best condition for you to manage and style. Shampoo is excellent at removing dirt and grease but used too often can remove the naturally occurring oil and change the pH or acidity which helps to keep hair in the peak of condition. Greasy hair is often the result of too much washing. The scalp over-compensates by trying to replace the oils that have been stripped from the hair during shampooing. Other factors, such as colouring and perms, may weaken the hair. Anxiety, illness, poor nutrition and some medication may cause the hair to become thinner.

Conditioners

With regular conditioning, it is possible to return shine and body to the hair; however, this tends to be surface treatment of the hair shaft. Months of washing and being

A healthy diet, rich in fibre, fruit and vegetables is the key to healthy-looking hair.

exposed to sun, wind and blow drying often means hair is in poor condition. Conditioners contain oils and waxes that help to smooth down the roughened surface of the hair shaft and coat the hair, restoring shine and body.

Head massage

If you can find the time, a daily head massage will encourage blood flow in the scalp. Using circular movements with the fingertips apply pressure to the scalp. Starting at the crown, work down the back of the head to the nape of the neck, then the sides to the temples and finally the top of the head to the forehead. With the knuckles gently tap the scalp to promote blood flow. Again using your fingertips apply gentle pressure to the points shown below. Applying simple acupressure can stimulate the scalp and also help to relieve tension.

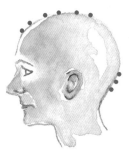

Pressure points on the head from the side

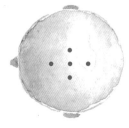

Pressure points on the crown of the head

Dandruff

Dandruff occurs when the scalp is irritated and can be caused by too much shampooing or by failing to rinse thoroughly. Dandruff needs to be treated very gently. Using very

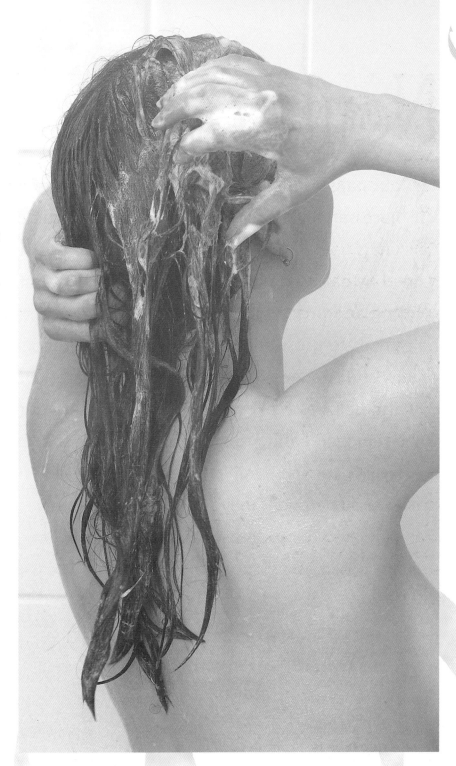

mild shampoo and thorough rinsing over time will often solve the problem. However, if problems persist seek medical advice.

Regular shampooing cleans and revitalises the hair but be careful not to strip its natural oils and leave hair dry and brittle.

Drying your hair

Avoid rubbing your hair with a towel as this will only scrunch and fluff up the hair shaft. Simply wrap a soft towel around your head and press gently, allowing the towel to absorb the moisture. Hair tends to be weak when wet, so avoid brushing it at this time. Instead, run your fingertips through your hair and gently remove tangles with a wide toothed comb to minimise fraying and split ends. Let your hair dry naturally where at all possible.

Nail care

Your nails consist mainly of protein but other vitamins are also necessary to prevent them becoming brittle or developing ridges. Calcium is a vital ingredient of strong nails as is vitamin A. The nutrients gained by eating green vegetables and fish help to prevent your nails from splitting and promote nail growth. Sulphur in the diet helps nails to grow and can be found in cucumber, onions and cabbage. Drinking plenty of water every day also helps as it allows waste products and toxins to be removed easily. Your genes, however, may be responsible for some nail problems and having brittle or strong nails may just be an inherited trait. Always seek professional advice if you are concerned about their health.

Healthy Nails

Hands and nails and always on show and should be given the same care and attention as the rest of your body. Use a fine emery board to file and shape your nails working in one direction from the sides of the nails to the middle; don't be tempted to use a sawing motion which can cause damage. (For a full manicure, follow the step-by-step routine shown). Orangewood sticks can be used to clean behind the nails and to gently push back softened cuticles. Cuticle-conditioning cream massaged into the base area of the nail will help to keep the cuticles soft. Alternatively, olive oil is an inexpensive substitute.

Nail strengtheners and hardeners are used as base and top coats respectively. These make the nail more resistant to splitting and breaking. The topcoat of hardener also helps to protect the applied nail polish.

Nail Problems

With all the use we make of our hands, it is surprising that our nails do not become damaged more often. However, following is a list of common problems and how you can help to relieve them.

Drink plenty of water and/or fruit juice to maintain healthly skin and nails.

Full manicure

2 Soak hands for 5–7 minutes in water containing a drop of camomile essential oil.

4 Use a good moisturising cream and massage it into the hands and especially the cuticles.

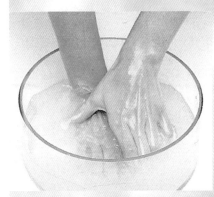

1 Wash your hands using a gentle soap in warm water and rinse thoroughly.

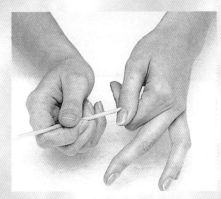

3 Dry your hands, massage a cuticle remover into the base of your nails and push back the cuticles using an orange stick.

5 If your nails are weak and tend to split or fracture, apply a nail strengthening solution followed by nail polish.

White marks on nails - caused by air bubbles trapped in the nail bed as the nail is formed. These white flecks will grow out naturally.

Weak nails - often the main reason is a poor diet, so whilst your nails wait to benefit from a better diet you can make them stronger by using a nail strengthener. Almond or olive oil rubbed into the base of the nail will help to stop them flaking.

Flaking nails - try not to trim with scissors, which stress the nail as they cut and cause fine fractures in the nail, instead use a fine nail file or emery board.

Splitting nails - file nails to a square shape rather than leaving pointed tips. This will help to reduce breaks and tears in the nail. Nail polish and strengthener will also help.

Bruised nails - although they are unsightly these will grow out naturally and will disappear in time.

Vertical grooves - these are down to your genes and there's not a lot you can do about it. Don't worry, only by very close examination do you notice and an application of several coats of coloured varnish will detract from the grooves.

Brittle nails - avoid plunging your hands in strong detergent and always wear rubber gloves. Wearing your nails short will also help. Gloves are essential when doing any physical work involving your hands and will protect your nails from injury.

Stains - stains on the nail surface or under the nail tip are unsightly and can be removed with lemon juice. To conceal staining under the nail tip use a nail tip whitening pencil. You can also apply a base coat first to stop stains caused by long term nail polish.

Health & hygiene

Daily cleansing routines, morning and evening, are the secrets to healthy-looking skin, nails and hair. To prevent blemishes, avoid touching your face with dirty hands and always adopt scrupulous bathroom hygiene practices. Because cosmetics have sell-by dates, limit your range of face and body products to the ones you use regularly. This way you will only use fresh products on your skin. Use disposable cotton and cleansing pads to apply make-up and other face products because it is more hygienic to use a new pad each time. Soak hair brushes and combs regularly in an antiseptic solution to prevent bacteria from growing.

The same basic health and hygiene rules apply with body art itself. Make sure you clean all your brushes as soon as you have finished a project. Make-up brushes should be washed in water mixed with baby shampoo, and to prevent cross infection do not share them with others unless the brushes are thoroughly cleaned.

Always do a skin test for any new products before you use them. Apply a little of the product to a small patch of your skin and leave the area for 24 hours to check that no reaction occurs. If there is any irritation or rash, wash off the product immediately.

To prevent make-up, henna or other products spoiling your clothes, cover them in an old towel while you are creating your designs.

The projects in this book are all designed to be temporary and removable. However, If you do choose to decorate your body permanently, e.g., with piercings or tattoos, always go to a reputable professional salon and follow their instructions on how to look after them.

Wash your brushes in water mixed with a little baby shampoo.

Keep surfaces and clothes clean with plenty of old towels.

Body painting

1

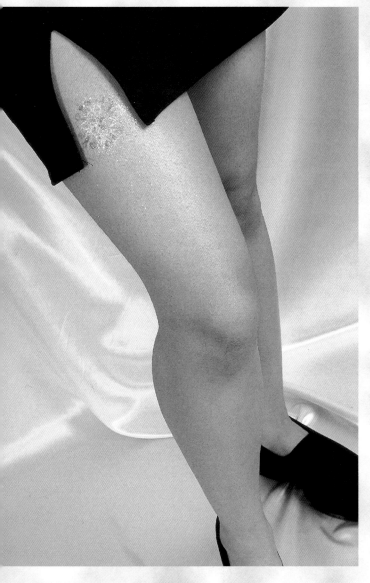

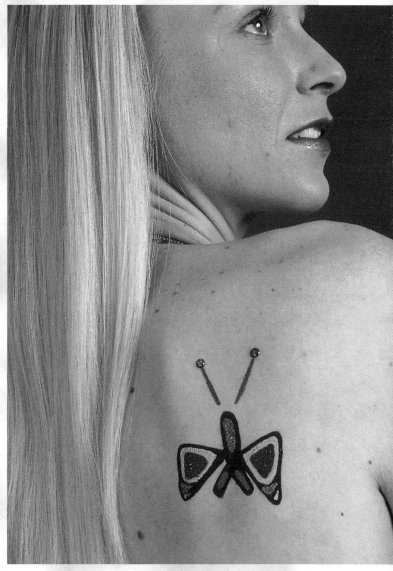

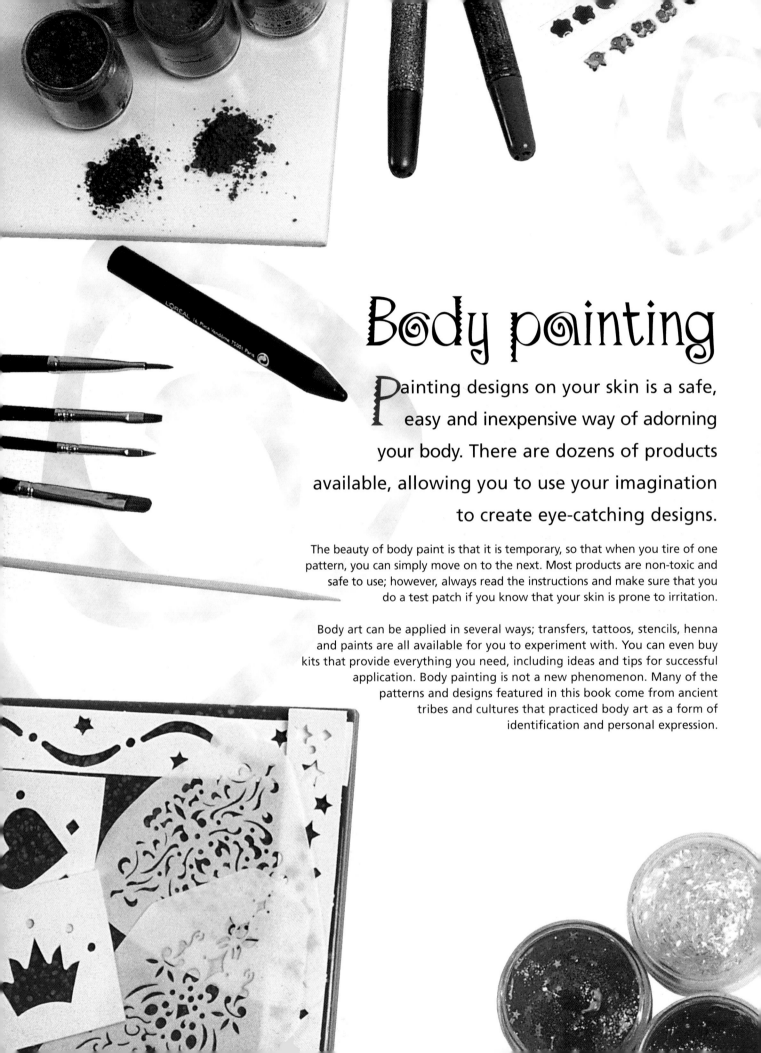

Body painting

Painting designs on your skin is a safe, easy and inexpensive way of adorning your body. There are dozens of products available, allowing you to use your imagination to create eye-catching designs.

The beauty of body paint is that it is temporary, so that when you tire of one pattern, you can simply move on to the next. Most products are non-toxic and safe to use; however, always read the instructions and make sure that you do a test patch if you know that your skin is prone to irritation.

Body art can be applied in several ways; transfers, tattoos, stencils, henna and paints are all available for you to experiment with. You can even buy kits that provide everything you need, including ideas and tips for successful application. Body painting is not a new phenomenon. Many of the patterns and designs featured in this book come from ancient tribes and cultures that practiced body art as a form of identification and personal expression.

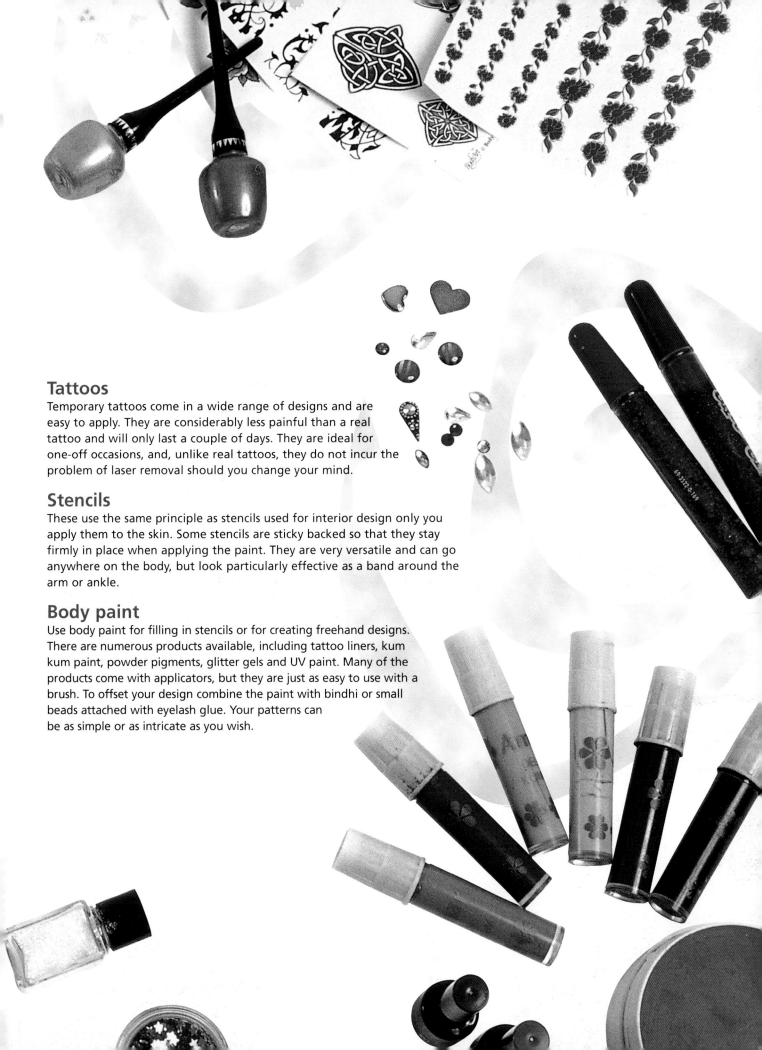

Tattoos

Temporary tattoos come in a wide range of designs and are easy to apply. They are considerably less painful than a real tattoo and will only last a couple of days. They are ideal for one-off occasions, and, unlike real tattoos, they do not incur the problem of laser removal should you change your mind.

Stencils

These use the same principle as stencils used for interior design only you apply them to the skin. Some stencils are sticky backed so that they stay firmly in place when applying the paint. They are very versatile and can go anywhere on the body, but look particularly effective as a band around the arm or ankle.

Body paint

Use body paint for filling in stencils or for creating freehand designs. There are numerous products available, including tattoo liners, kum kum paint, powder pigments, glitter gels and UV paint. Many of the products come with applicators, but they are just as easy to use with a brush. To offset your design combine the paint with bindhi or small beads attached with eyelash glue. Your patterns can be as simple or as intricate as you wish.

Oriental mystery

Chinese characters make simple but effective designs that are a good introduction to painting freehand. They can be drawn anywhere on the body. For this neck design, however, you will probably need a friend to help you. Once you have a feel for applying freehand designs, try creating your own.

You will need
- cotton pad and water
- black temporary tattoo liner
- small brush or applicator

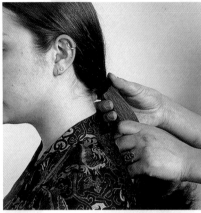

1 Brush and tie your hair back to reveal the area of your neck to be decorated.

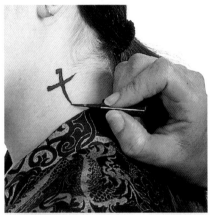

3 Using the brush and tattoo liner, draw sweeping strokes in the shape of a large cross.

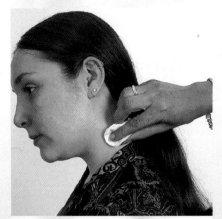

2 Clean your neck with a cotton pad soaked in water, leaving the skin dry and free of oil and make-up.

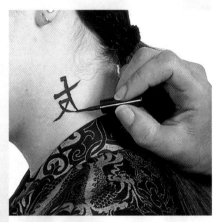

4 Once the first part of the design is dry, draw the second element by painting the smaller 'x'. Finish with a line across the top.

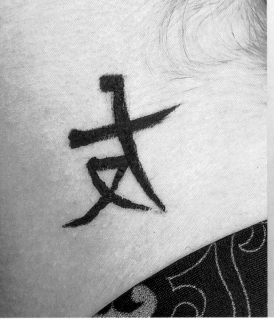

Tip
- If you make a mistake simply wipe away the liner with a moist cotton bud and start again.

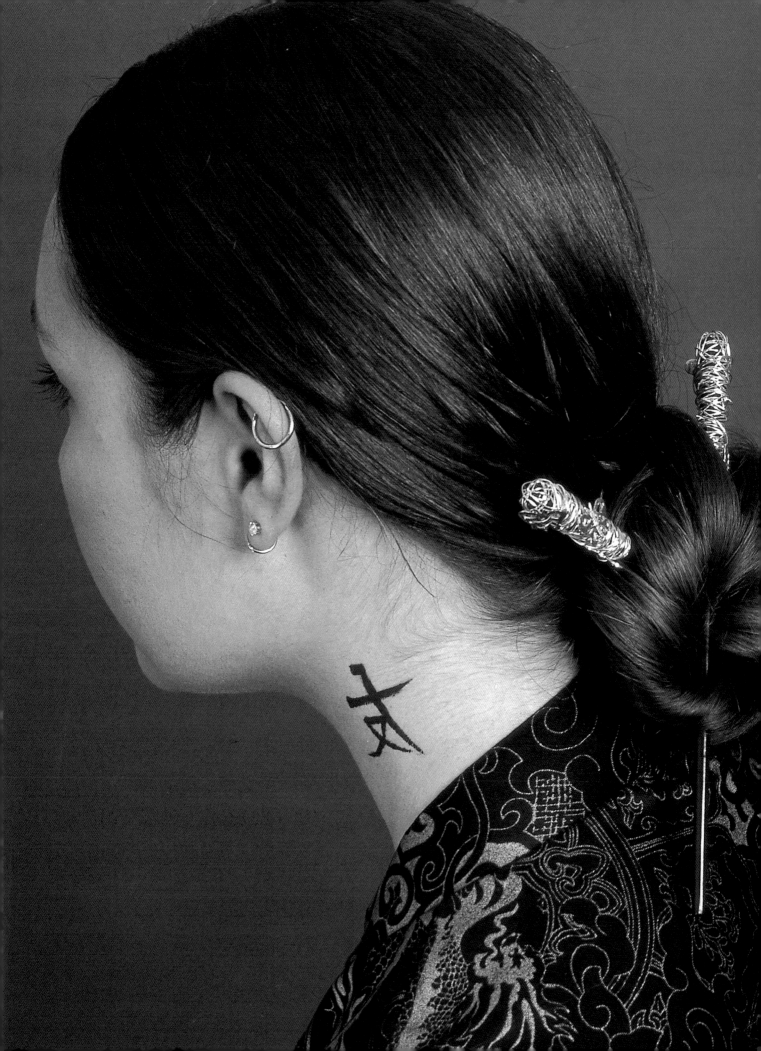

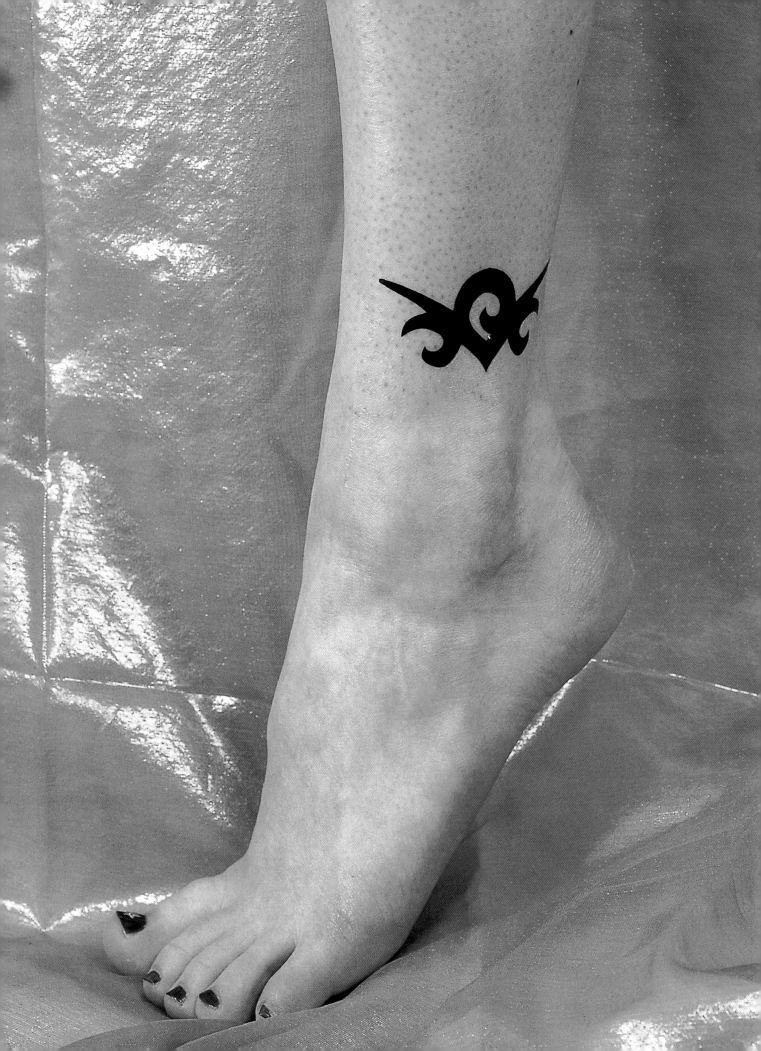

Ankles away!

Temporary tattoos and stickers are among the quickest and easiest of body decorations to apply and can be incredibly striking. This project is ideal for the summer when you can flaunt your toes and ankles with open-toed sandals or even go bare feet.

You will need
- temporary tattoo
- sponge or cotton pad and water
- deep blue nail polish
- nail stickers

1 Peel off the plastic sheet from the front of the temporary tattoo.

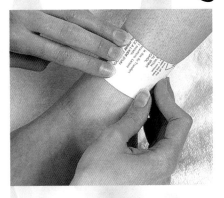

2 Position the tattoo face down on your leg, just above the ankle bone.

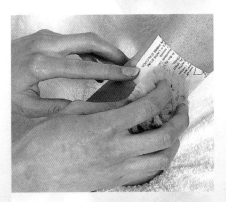

3 Soak the back of the tattoo with a damp sponge or cotton pad. Leave for 30 seconds.

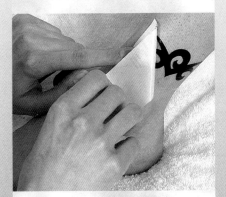

4 Carefully peel off the backing paper to reveal the tattoo underneath.

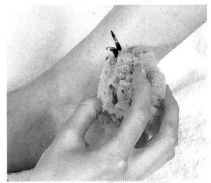

5 Dab the tattoo lightly with the moist sponge to check that it is firmly stuck to the skin.

6 Wedge cotton wool between your toes to separate them and paint your toe nails using deep blue nail polish.

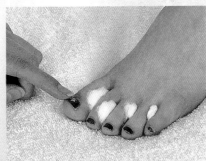

7 Once the polish is dry, peel a nail sticker from its backing sheet and press firmly into place on the big toe.

Tip
- To keep the nail sticker in place longer apply a coat of clear nail varnish on top.

In the swim

Achieve a mystic look in seconds with this temporary tattoo. With larger designs you can fill in the detail using coloured body paints as we have done here. You could also try combining tattoos with your freehand designs.

You will need
- temporary tattoo
- sponge and water
- red body paint and applicator

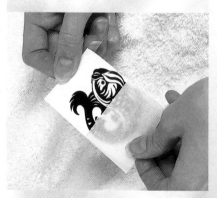

1 Peel off the transparent sheet from the front of the temporary tattoo.

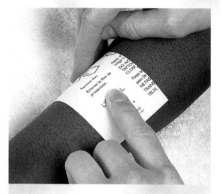

2 Ensure the skin on your forearm is clean and dry and then place the tattoo face down onto the arm pressing firmly.

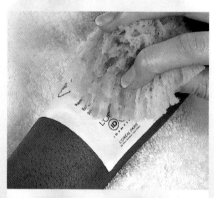

3 Wet the back of the tattoo thoroughly with a damp sponge and wait for 30 seconds.

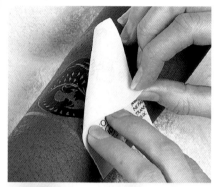

4 Gently peel off the backing paper to reveal the tattoo underneath. Dab the tattoo again using the moist sponge to make sure it is firmly fixed.

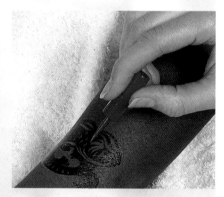

5 Once the tattoo is dry, paint in the detail with red body paint to enhance the design.

Tip
- To keep your tattoo looking fresh for as long as possible, avoid using lotions and oils on or around the design.

Crowning glory

This design can look delightful when subtle stencil paints are used to give a regal, sophisticated appearance. Soft, pastel shades are effective, although stronger colours will be better for a night-time look. Many types of stencil can be used to create body art, but stencils with non-toxic sticky backs are the easiest to use.

You will need
- stencil
- pink, purple and gold body powders
- water
- small brush

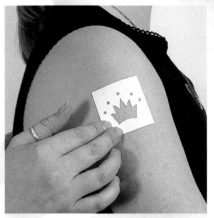

1 Peel the backing paper off the stencil and press the stencil firmly into place on the upper arm.

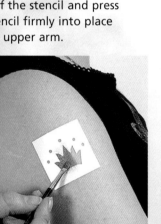

2 Mix the pink body powder with a small amount of water to make the paint. Use this to paint the crown area of the stencil.

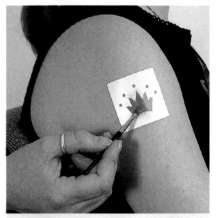

3 Mix the purple powder with water and use it to fill in alternate dots above the crown.

4 Repeat with the gold colour powder to fill in the remaining dots.

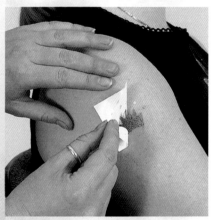

5 Leave your design to dry and then carefully peel off the stencil. It will be easier if you start at one of the corners. Continue peeling until you have completely removed the stencil to reveal the design.

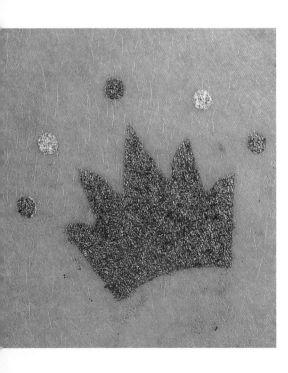

Tip
- Always read the labels of any paint you use to check it is suitable for use on the skin.

Queen of hearts

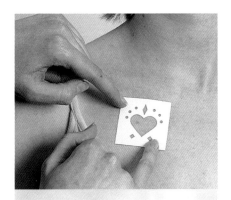

1 Peel off the backing paper and position the stencil onto the breast bone. Press firmly into place.

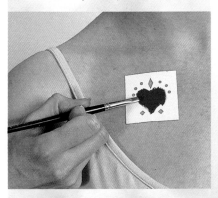

2 Colour in the heart shape of the stencil using the red Kum Kum.

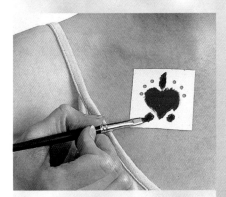

3 Paint the shapes above and below the heart with the purple Kum Kum.

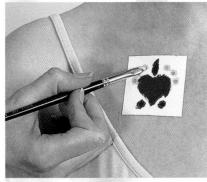

4 Finally, fill in the remaining dots above the finished heart design with the yellow Kum Kum.

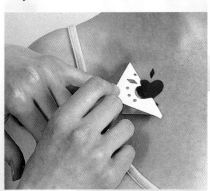

5 Leave the paint to dry and then gently peel off the stencil.

T o get the best effect from this attractive stencil, wear flattering clothes such as strappy tops that draw attention to the design. We have painted this heart in a traditional red colour, but you could change the colour of your heart to suit your mood.

You will need
- stencil
- red, purple and yellow Kum Kum paint
- small brush

Tip
- To make sure the colours stay bright and clear, wash your brush thoroughly between paints.

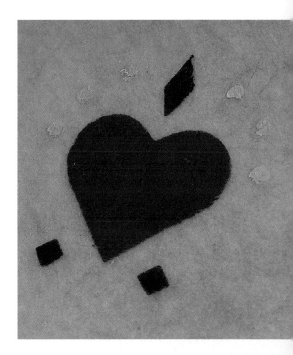

Pretty in pink

Self-adhesive beads are fantastic for adding sparkle to simple designs. This effective arm band combines them with the technique of stencilling. If you wish to be even more adventurous, you can repeat the pattern downward to give the illusion of a spiral around your arm. The beginning and end of each stencilled band should be hidden on the back of your arm.

You will need

- arm band stencil
- pink, blue and gold body powder
- water
- small brush
- self-adhesive beads

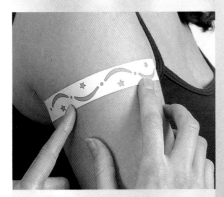

1 Place the self-adhesive stencil around your arm and press it firmly into place, ensuring that neither end of the stencil is visible.

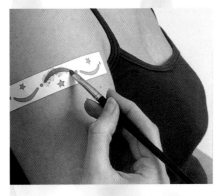

2 Mix the pink body powder with water to make paint and fill in alternate waves using a small brush.

3 Clean the brush and then apply blue pigment paint to the remaining waves.

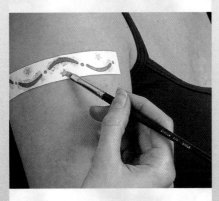

4 Next fill in the small stars with paint made from the gold pigment.

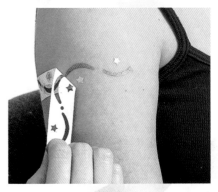

5 Once the paint is dry, carefully peel off the stencil to reveal the pattern.

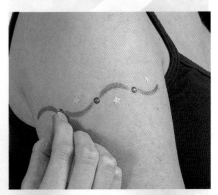

6 For the final touch, stick colourful self-adhesive beads between the painted waves.

Tip
- If you are in a hurry for your stencil to dry, try using a hairdryer on a cool setting.

Thigh and dry

Once you've mastered the art of stencilling, why not be a little more risqué and put a stencil on your thigh? The stencil for this project didn't come with a sticky back so we used a little eyelash glue to stick it temporarily in place.

You will need
• stencil and eyelash glue
• pink, blue, gold and purple body powder and water
• small brush
• glitter dust

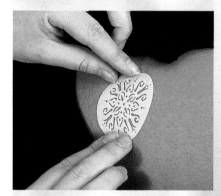

1 Apply a little eyelash glue to the back edges of the stencil and stick into place on your thigh.

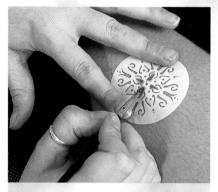

2 Using a small brush mix the pink powder with the water and paint your chosen part of the stencil pattern.

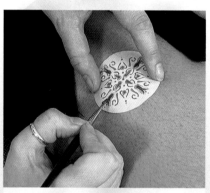

3 Clean the brush, mix the blue powder with water and paint another area.

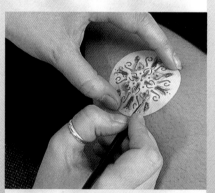

4 Select other parts of the stencil to fill in with the gold powder paint mix.

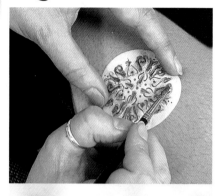

5 Paint the final sections with the purple colour and leave to dry.

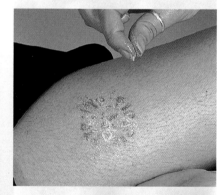

6 Carefully peel away the stencil and sprinkle lightly with glitter dust.

Tip
• If a little eyelash glue remains on your skin once you have removed the stencil, use a cotton bud dipped in nail-varnish remover to wipe it away carefully.

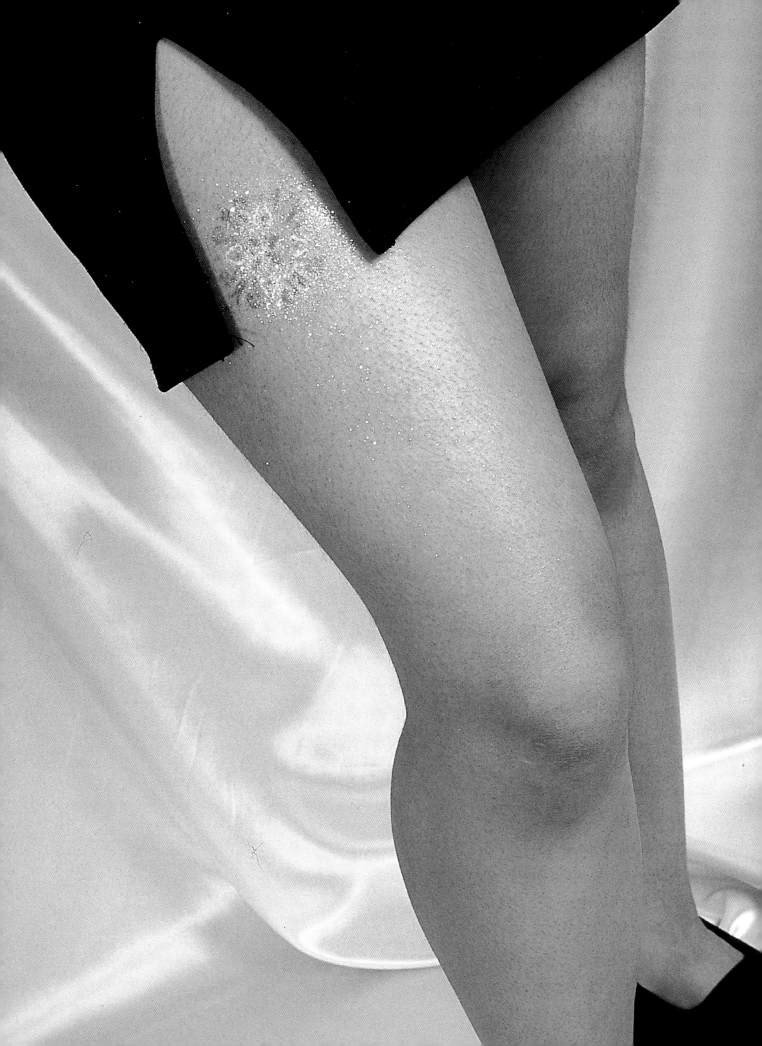

Star struck

You don't always have to buy special products to create body art. If body paint is expensive or difficult to get hold of, try experimenting with make-up products you already own. For this project we actually used hair mascara as a body paint. However, always check the manufacturer's instructions carefully before you use a product on a different part of the body to ensure that it is safe to use.

You will need
- silver nail varnish
- self adhesive star stencil
- green, blue and gold hair mascara
- small brush

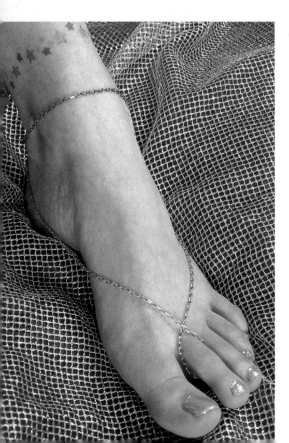

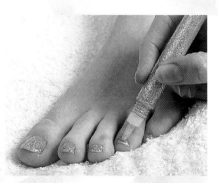

1 Carefully apply silver nail varnish to your toe nails and leave to dry.

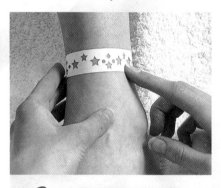

2 Peel the backing paper off the self-adhesive stencil and position firmly in place around the ankle.

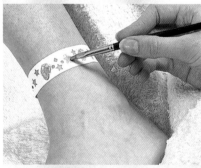

3 Use a brush to apply green hair mascara to the largest stars of the stencil.

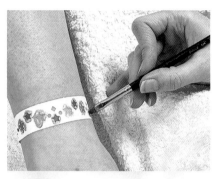

4 Clean your brush and paint the smaller stars with blue hair mascara.

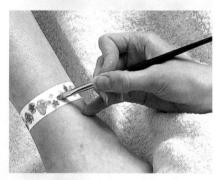

5 Finally, paint the remaining areas with gold hair mascara.

6 Once the mascara has dried, carefully peel off the stencil to reveal the pattern underneath.

Tip
- Use an old towel to rest your foot on and to protect surfaces underneath from paint and nail varnish.

Flower power

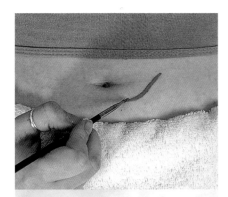

1 Keeping your hand steady paint the flower stem in one long stroke.

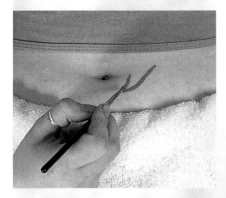

2 Next, paint a leaf to the left of the stem with a second stroke.

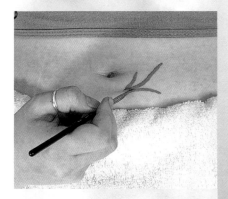

3 Then paint a second leaf on the right of the stem to join at the base.

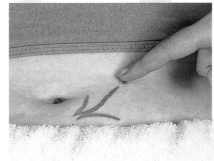

4 Position a self-adhesive bindhi at the top end of the stem to represent the middle of the flower and press firmly into place.

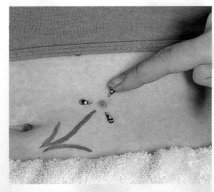

5 Finally, press five tear-shaped bindhis in place around the centre to create the petals.

Tip
• Avoid placing the flower where clothing may rub against the design causing the bindhis to fall off.

With this design your tummy will be very much the centre of attention. Again we've combined techniques and used Kum Kum paint with stick-on bindhis to create a very flattering design.

You will need
• green Kum Kum paint
• small brush
• 1 circular bindhi
• 5 tear-shaped bindhis

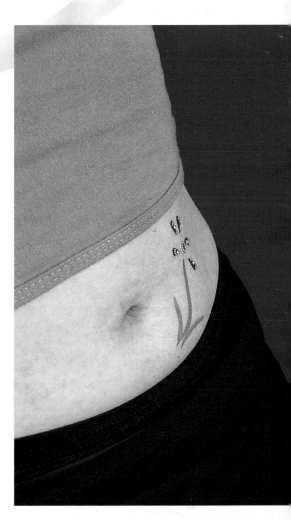

Face to face

In this project we used Kum Kum on the face which is where it is traditionally worn by Asian brides during their marriage ceremonies. This project is a good example of how you can take traditional materials and give them a more contemporary feel.

You will need
- cosmetic sponge
- foundation
- small brush
- green, red, white and purple Kum Kum
- 2 matching stencils
- pink eyeshadow
- flat brush
- black lash liner
- pink blusher
- red glossy lipstick

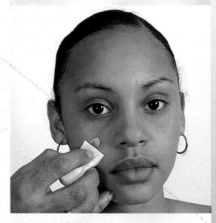

1 Smooth a little foundation evenly over your face using a sponge.

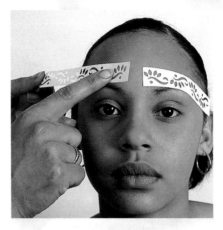

2 Position the stencils on your face above each eyebrow making sure they match evenly.

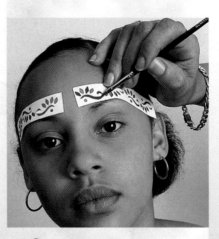

3 Using a small brush apply red Kum Kum to part of each stencil. To give a symmetrical look, remember that the areas you paint on the left side must be mirrored on the right.

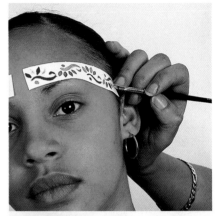

4 Repeat the process so that the remaining areas are coloured in with green, white and purple Kum Kum.

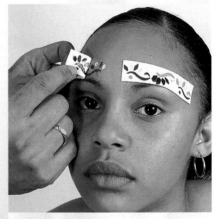

5 When the paint has dried remove both stencils being careful not to drag the skin and the stencil design.

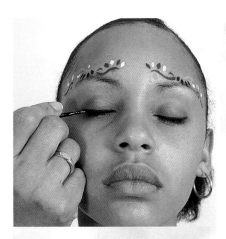

6 Apply pink eyeshadow to the eye lids and finish off the look with some black lash liner, blusher and lipstick.

Tip

• If you don't have two stencils that mirror each other, use your chosen stencil to complete the design on one side of your face and then simply wash and reverse the stencil to use on the other side.

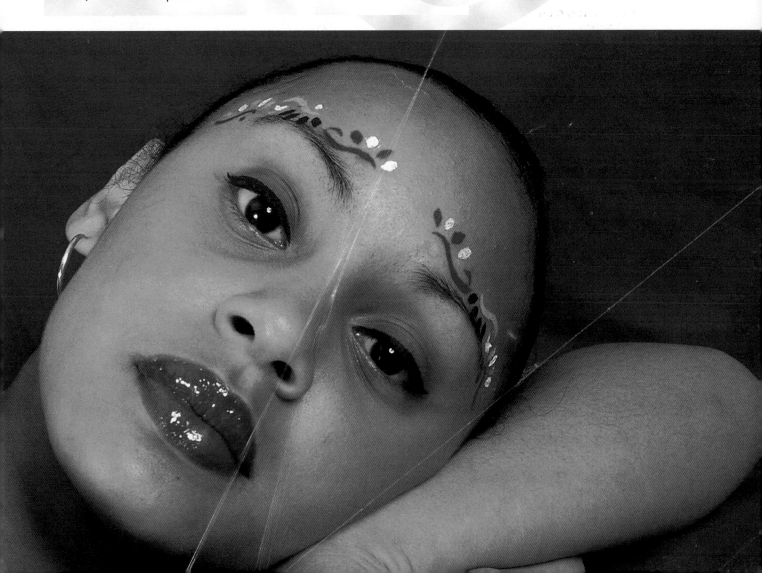

Scroll over

Bright colours are no longer just used for parties, they can also be worn as day make-up. Stick-on gems, body paint and glitter paint can be combined to create effective designs for any occasion.

You will need
- green glitter body paint
- blue body paint
- stick-on gems
- small brush

2 Dry the area thoroughly with a towel.

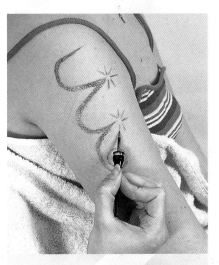

4 Add blue flower petals in short straight lines to the pointed ends of the curves.

1 Cleanse the arm with a cotton pad dipped in a little water.

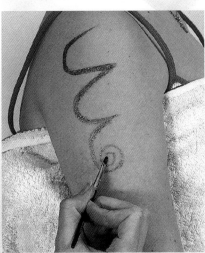

3 Use green glitter body paint to draw a continuous curve from the top of the arm to the elbow and finish with a spiral.

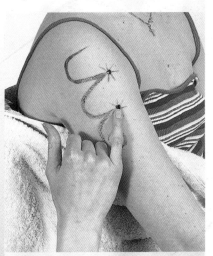

5 Apply stick-on gems to the centre of the flowers and press firmly in place.

Tip
- If you don't have any glitter paint, draw the design with body paint and while it is still wet sprinkle with glitter dust.

Flutterby butterfly

You don't have to be a great artist to draw freehand designs. This butterfly was created using very simple shapes, but by using bright glitter colours and adding detail with beads, a stunning effect was achieved.

You will need
- black tattoo liner
- cocktail stick
- small brush
- green, gold, pink and blue glitter paint
- stick-on beads

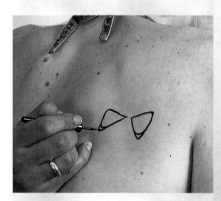

1 Use black tattoo liner to draw the triangular wings of the butterfly.

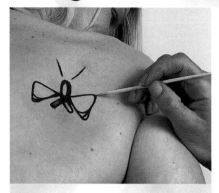

2 Then draw the body and legs. Use the cocktail stick to draw the thinner lines of the antennae.

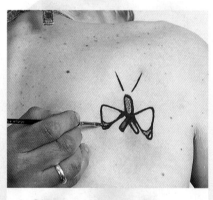

3 Fill in the body and wing sections of the design with green glitter paint.

Tip
- If you are finding the design difficult, try drawing the outline with faint dots and then joining these with straight lines.

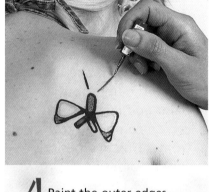

4 Paint the outer edges and tips of the wings with the gold and highlight antennae and legs with pink.

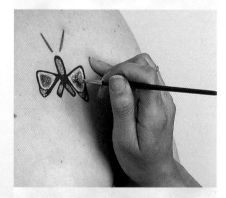

5 Finish off the centre of the wings with blue glitter paint.

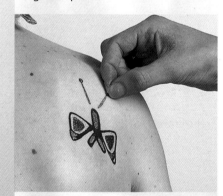

6 Finally, place bindhis at the end of the antennae and press firmly.

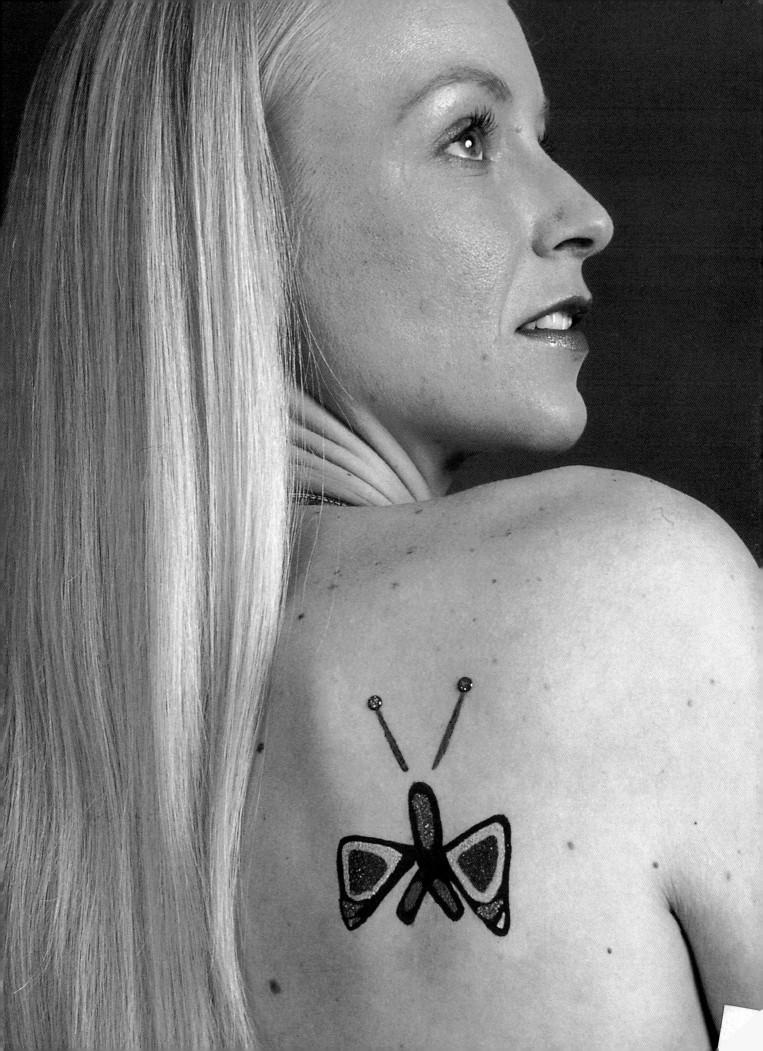

Light fantastic

Ultra violet body paints are available in make-up and fancy-dress shops and also from television and theatrical make-up suppliers. UV products are attractive in daylight but really come to life under the UV lights of clubs and discos where they glow with fabulous luminosity. To achieve the best effects, keep the designs simple.

You will need
- UV body paint
- small brush

1 Using UV paint, draw the shape of a circle on the upper arm.

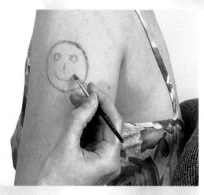

2 Draw eyes, nose and mouth in the circle with a small brush.

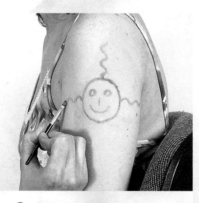

3 Using a small brush paint wavy lines upwards from the circle and to the sides.

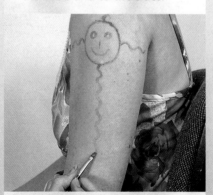

4 Paint a longer wavy line from the bottom of the circle towards the elbow.

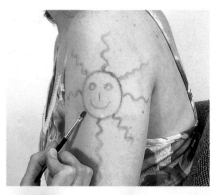

5 Draw further wavy lines in the gaps. Try to keep all lines the same length.

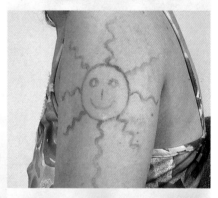

6 Get ready to turn out the lights! Remember the design will only glow in the presence of UV light.

Tip
- To prevent the UV paint from cracking, paint over the finished design with some clear nail polish.

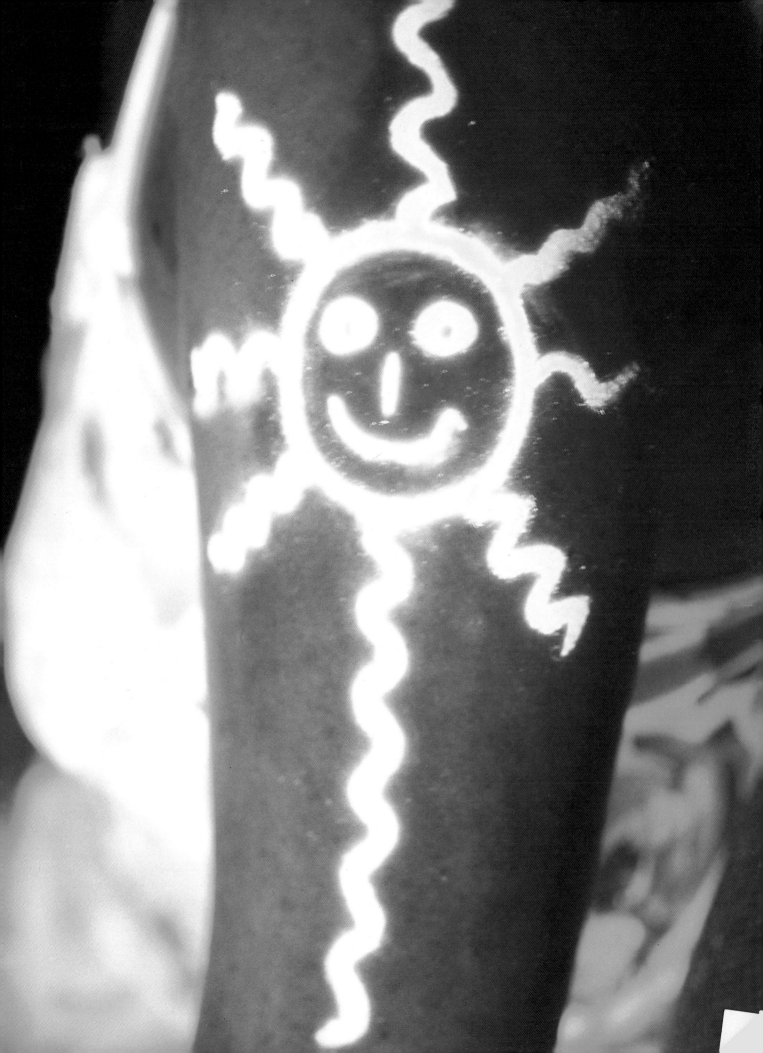

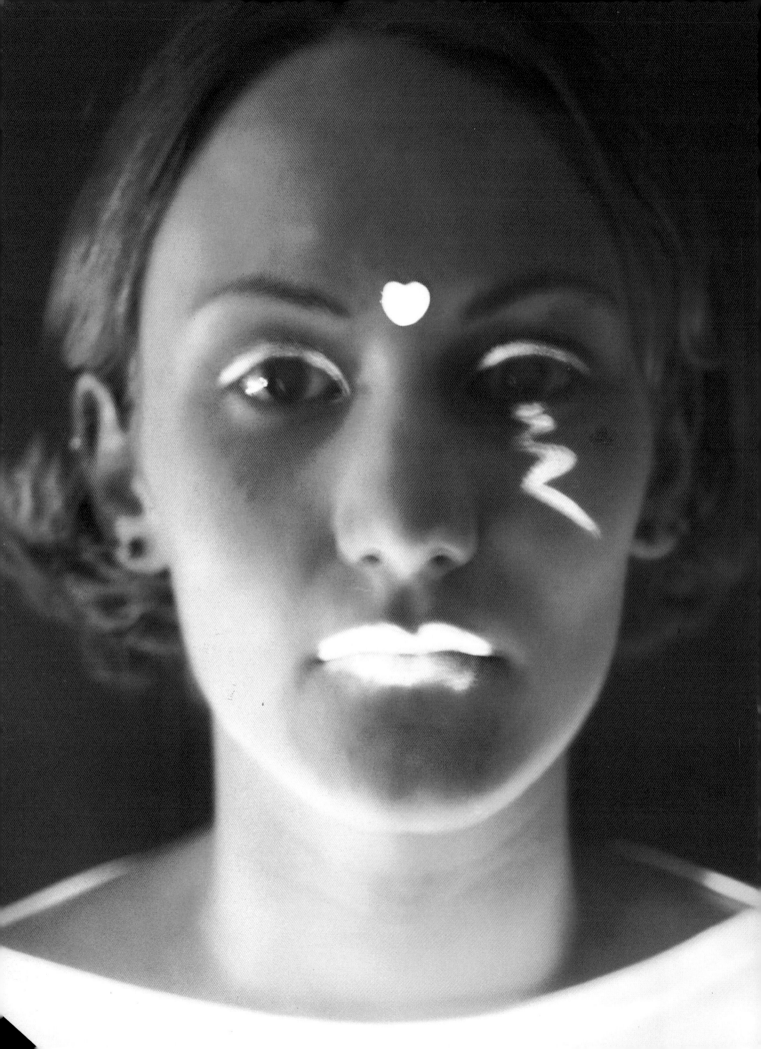

All aglow

You will definitely be stepping into the limelight with this design - UV paint is not for the faint-hearted. This make-up is bold so wear it with confidence.

You will need
- orange UV paint
- small brush
- 'glow in the dark' jewel
- eyelash glue
- orange UV lip block
- petroleum jelly

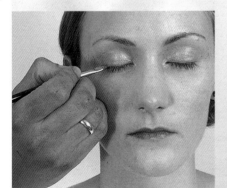

1 Using a small brush, apply UV body paint as an eye liner to both eyes.

2 Then draw a zig-zag pattern under the left eye with steady strokes.

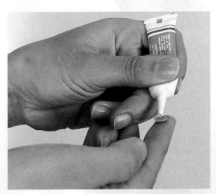

3 Apply a little eyelash glue to the back of a 'glow in the dark' jewel.

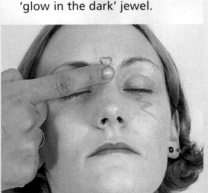

4 Position the body jewel between the eyebrows and press firmly in place.

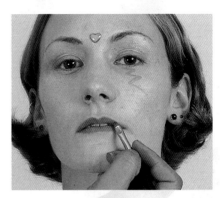

5 Apply orange UV lip block to the lips.

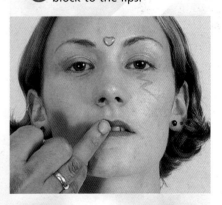

6 Cover the lips with a little petroleum jelly to stop the lip block from cracking.

Tip
- For best effects, wear light coloured clothing which will glow under UV light along with your paint.

Flower girl

Body painting doesn't have to be outrageous. Try this subtle and delicate design, which placed on the shoulder, can be very alluring. Flower patterns often look good in an array of wonderful colours.

You will need

- cotton pad and water
- green, purple Kum Kum
- cocktail stick
- hair clip
- small brush

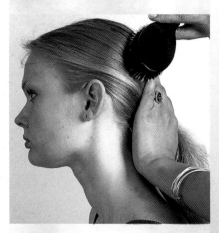

1 Brush and clip your hair back to make it easy for you to apply your design.

2 Cleanse and dry the area thoroughly where your design will appear.

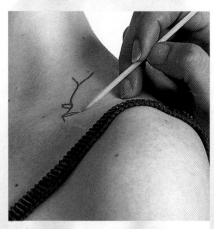

3 Slowly build up your flower design. Firstly paint the stems of the flowers and a couple of leaves with the green Kum Kum.

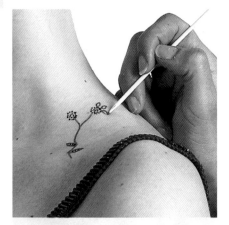

4 Fill in the leaves with purple paint and create the centres of your flowers with tiny dots. Start to paint pink petals around the centre.

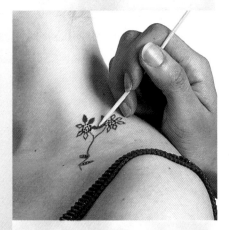

5 Continue painting petals until both flowers are complete. Try to keep the petals equal in size.

Tip

- Draw in the outline of the flower first to act as the guide for your finished design.

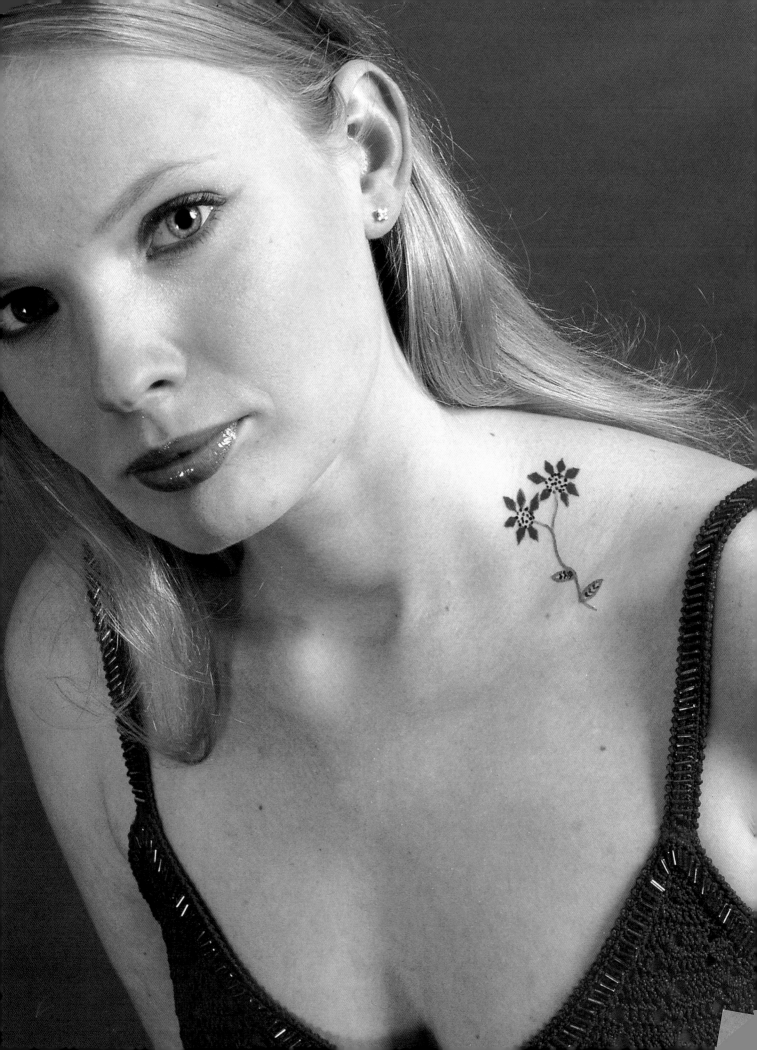

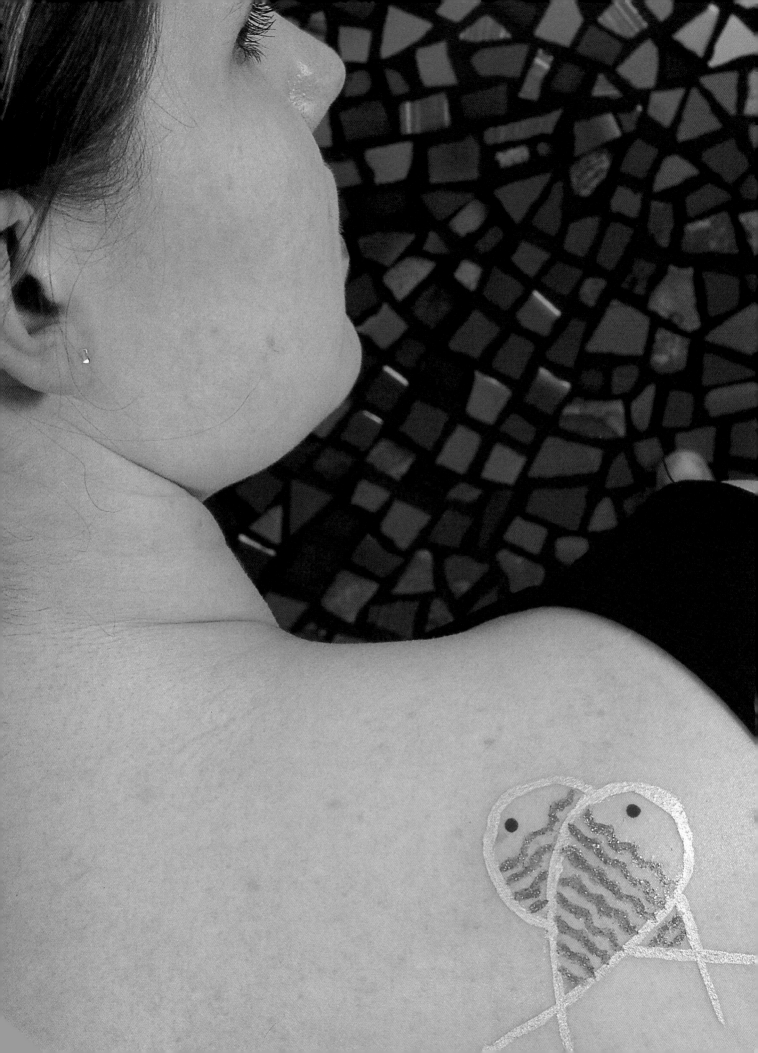

Fish out of water

Fish shapes are simple to paint, and as you become more confident in applying body make-up, you can experiment by giving the fish designs a background - even painting a blue base on to the skin to represent the ocean. A whole marine theme is possible, so why stop at fish when you can paint seahorses, dolphins and whales?

You will need
- cotton pad
- water-based silver-fluid body paint
- small brush
- green glitter paint
- red Kum Kum

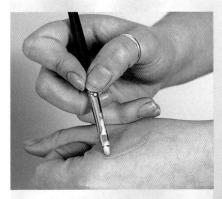

1 Test the consistency of the paint on the back of the hand and shoulder blade.

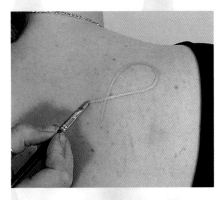

2 Carefully draw an outline of the fish using the silver body paint.

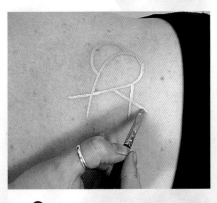

3 Develop the design by crossing the outline of a second fish under the first.

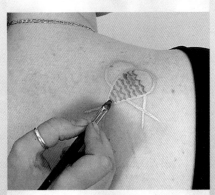

4 Paint a scale pattern in the body of the fish using green glitter paint.

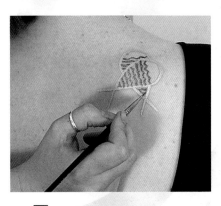

5 Complete the scales of both the fish.

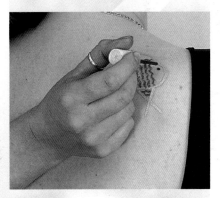

6 Give each of the fish an eye by painting a small dot using red Kum Kum.

Tip
- Shake the Kum Kum well before use to make it creamy and easy to apply.

Jewelled flower

This is an intricate design that looks fabulous. However, it is not as hard as it looks. It is based on very simple shapes, and it is the creative use of bindhis, beads and the blend of colours that makes it so stunning.

You will need
- tattoo liner
- cotton cleansing pad and water
- cocktail stick
- fine brush or the applicator that comes with the tattoo liner
- colourful beads and bindhis
- eyelash glue

1 Clean the arm with a cotton pad and water.

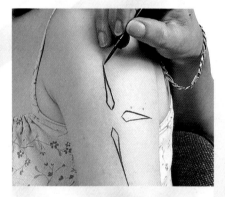

2 With a small brush draw four kite shaped petals around an imaginary centre with the tattoo liner.

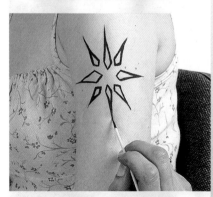

3 Paint four more petals between these and use a cocktail stick to fill in any gaps in the lines.

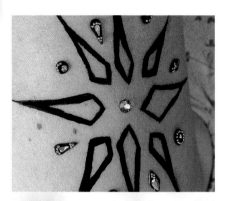

4 Stick a bead in the centre of the jewelled flower using eye lash glue. Then stick an assortment of bindhis in the gaps between the petals.

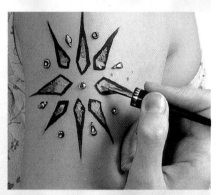

5 Colour in the petals with tattoo liner taking care not to smudge the edges of the petal. Use more than one colour for each petal.

Tip
- Instead of tattoo liner, you can use Kum Kum mixed with a little glitter.

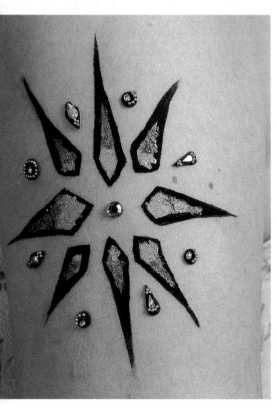

2

Henna

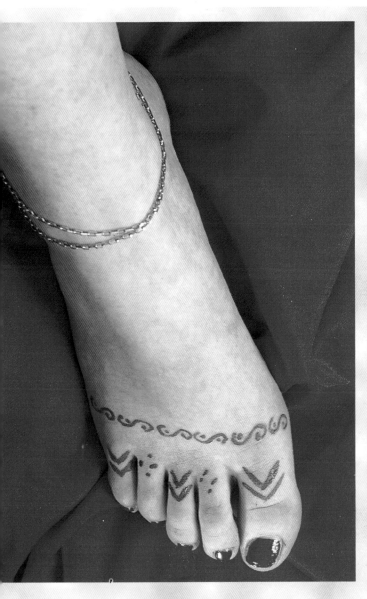

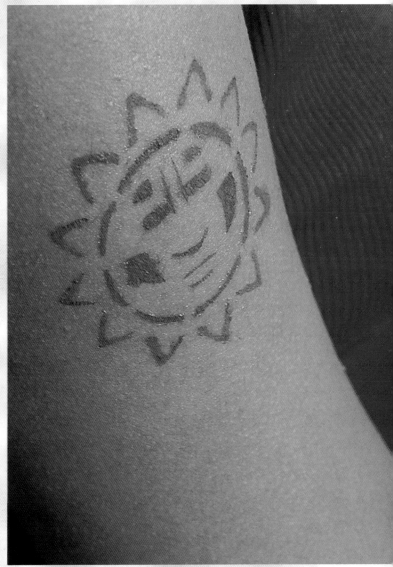

Henna

Mehndi has now been recognised in western cultures alongside tattooing. This is a popular way of decorating the skin without having to experience the pain of tattooing.

Used by women in Asia, staining the skin and hair with henna is a popular beauty-enhancing treatment, reserved for special occasions because of its intricate and time consuming nature. At weddings the bride would have a henna design drawn all over her arm and the groom would have to search for his name incorporated within the design. Red henna is used for the tips of the fingers and the back of the hands whilst black henna is more often used on the soles of the feet and palms of the hands.

Henna is derived from a plant called *Lawsonia inermis,* and it is the shoots and leaves which when mixed with *catechu,* obtained from various other shrubs, dried and powdered, yields the henna powder that we are familiar with in the West. The application of henna is a long process so plan ahead and allow plenty of time for the henna to take.

Originally henna had a medicinal use in cooling the body. During times of excessive heat the palms and feet were painted with henna to try and reduce the body's temperature. Henna is a stain and the colour of individual henna patterns may vary depending on the length of time the henna has been left in place. If mixed with coffee and left for over 24 hours it will give a darker henna pattern. The shorter the time henna is left on the skin, the lighter the tattoo and the sooner it will wear off. Both red and black henna can usually be purchased from your local grocery store. It has also been brought to the forefront of fashion by popstars, such as Madonna and Janet Jackson, who have Mehndi drawn on their hands as part of their look. They have also highlighted the whole Asian experience by wearing Bindhis and Asian jewellery (i.e., nose rings and chains from nose to ear) as a fashion statement and turned it into a global trend.

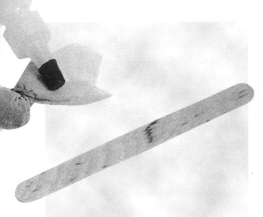

How to mix Henna paste

Henna is readily available as a powder or ready-made as a paste.

Henna paste

Attach nozzle to the end of the tube of henna paste and apply directly on to the skin. Create designs of your choice and leave to dry. Henna paste is dry when it starts to crumble on the skin.

Henna powder

You will need:
Henna powder
Plastic bowl for mixing
Spoon
Water
Lemon juice

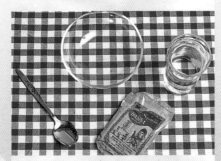

1 Place several tablespoons of henna powder into a bowl or container. Remember henna is a powerful stain, so protect surfaces with an old cloth or towel.

2 Add water and mix into a paste. Try to achieve a paste with a smooth, lump-free and creamy consistency, which is not runny.

3 Add two teaspoons of coffee to the mix and two drops of lemon juice. The lemon helps the henna to stain more deeply into the skin and the coffee makes the stain darker. Leave the henna paste overnight so the mixture can develop.

Hand on heart

Henna, or Menhdi, is a popular form of decoration for Asian brides. They are normally done freehand but you can use stencils which are usually very intricate with a wide variety of designs. They are made of plastic for ease of application and the effect will last for a few days, or even weeks, depending on the strength of the henna paste.

You will need

- sticky backed hand stencil
- henna paste
- small brush
- damp cloth
- scissors

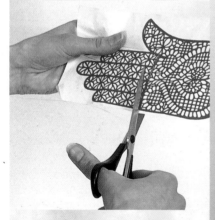

1 Cut the stencil into pieces ready before you apply it to the hand.

2 Cut the fingers sections from the main body of the stencil.

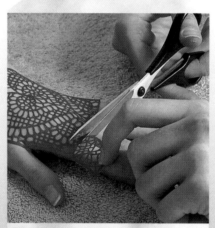

3 Peel off the back of the stencil and carefully position on the hand. You may need to trim the edges of the stencils to fit on the hand.

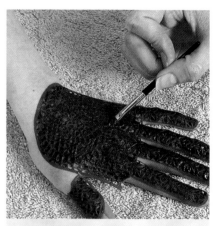

4 Mix up the henna (p.51) and apply to the gaps in the stencil with a small brush. Take time to apply the henna, making sure that you have filled in all the gaps.

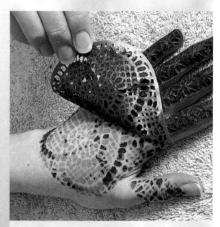

5 Carefully peel back the stencil to reveal the henna design underneath.

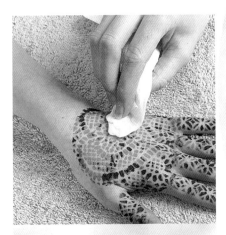

6 Wipe off henna residue with a damp cloth. Leave for a minimum of three to twelve hours to get the strongest colour.

Tip
• Mix three teaspoons of instant coffee granules with your henna paste for a darker henna colour.

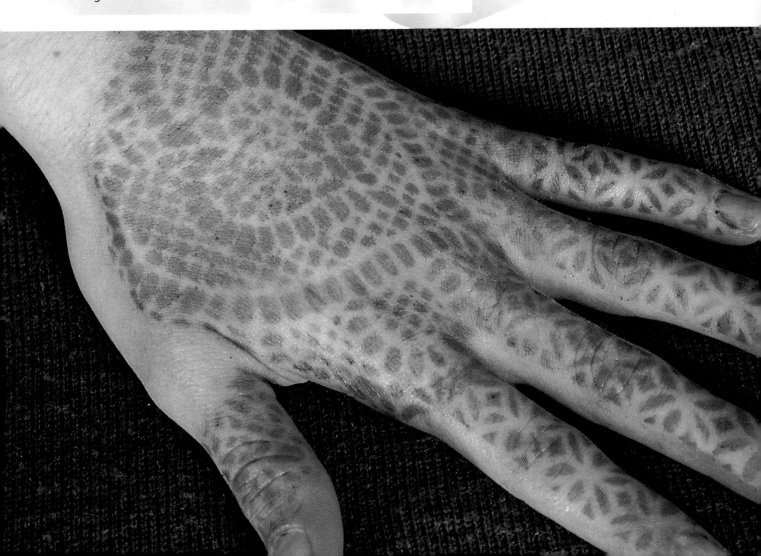

Hello sunshine!

Stencils are made in many different shapes and styles. You can choose a stencil to suit your mood. You could even place the moon stencil (p. 57) around your navel to complement the sun.

You will need
- sticky-backed sun arm stencil
- henna paste
- brush
- cotton pad

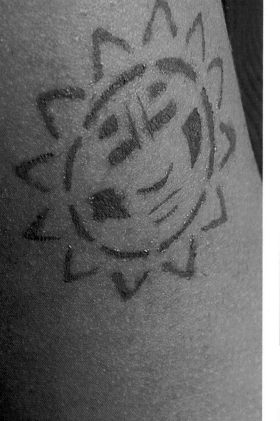

1 Cleanse the skin using water and cotton pad and towel dry.

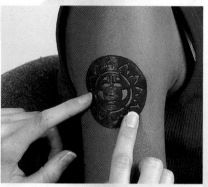

2 Peel the backing off the stencil and position the stencil on the arm.

3 Apply henna mix evenly through the gaps of the stencil onto the skin using a small brush.

4 Peel off the stencil carefully revealing the sun design underneath.

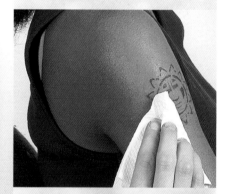

5 Wipe off the excess henna with a damp cloth or cotton pad.

Tip
- To brighten the stencils you could fill the design with a little orange UV body paint.

Henna leaf pattern

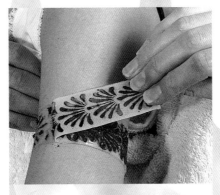

This armband stencil is a simple design that will take minutes to apply. Repeat patterns work well on armbands and may last up to two weeks. You can also use these bands around the ankle or wrist.

1 Cleanse area using a cotton pad and water and then dry with a towel.

4 Allow several hours for the henna to take. Peel off the stencil when the henna has dried

You will need
- Sticky-backed arm stencil
- henna paste
- cotton pad

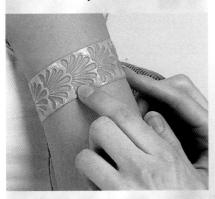

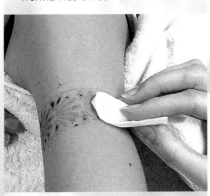

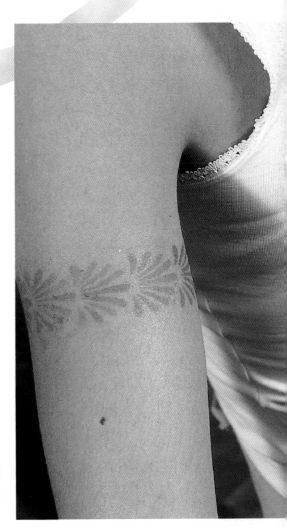

2 Apply the stencil to the arm in an even circle. Press stencil firmly in place ready for the paste.

5 Carefully wipe of any residue with a damp cloth or cotton pad.

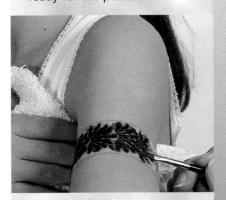

3 Apply your ready-mixed henna to the gaps in the stencil with a brush.

Tip
- Henna will stain so use an old towel to protect your clothes from the paste.

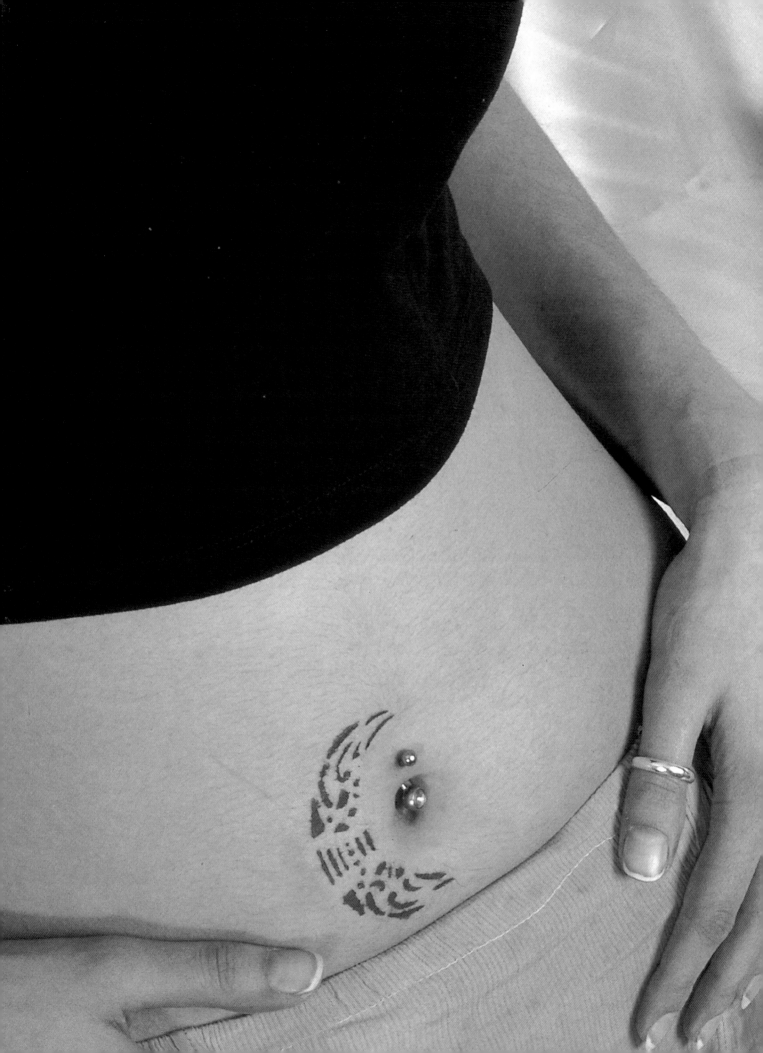

Crescent moon

Tummy adornments have become increasingly popular with the introduction of piercings, tattoos and body paint. Henna is another effective form of body decoration, which is both temporary and painless! Set off with a cropped top and hipster trousers, you can achieve an all-summer look.

You will need
- stencil
- henna paste
- small brush
- cotton pad

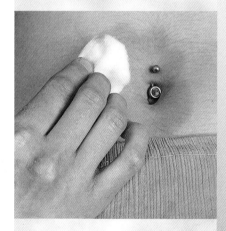

1 Cleanse area with a cotton pad and water and dry with a towel.

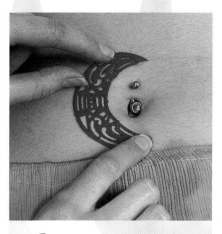

2 Peel the back of the stencil and place it around the tummy button.

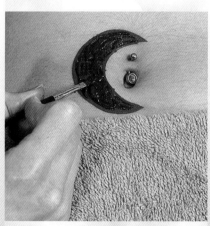

3 Apply the henna paste through the gaps on the stencil with a brush. Leave for several hours.

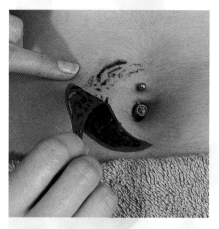

4 Carefully remove the stencil revealing the intricate design.

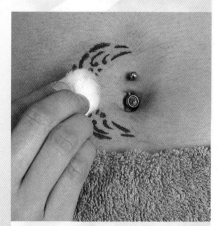

5 Wipe off excess henna with a cotton pad and water and allow to dry.

Tip
- If the henna does not colour the skin evenly, repairs to the henna design can be done by using a brown tattoo liner.

Scroll on!

Once you are familiar with the technique of applying henna stencils, you can start to experiment with freehand designs. These require a steady hand so practice on paper first to be sure you can achieve a more even result when applying to the skin.

You will need
- tube of henna paste with
- nozzle
- small brush
- damp cloth
- cotton pad

1 Cleanse the area with a cotton pad and water and then dry with a towel.

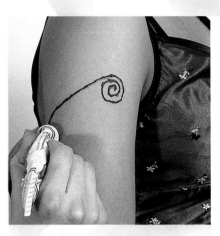

2 Apply the henna paste in one easy movement creating a scroll design starting in the middle of the scroll working outward.

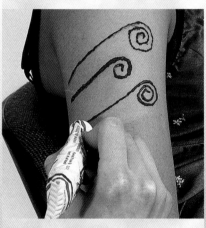

3 Apply more scrolls of varying lengths using a small brush or nozzle.

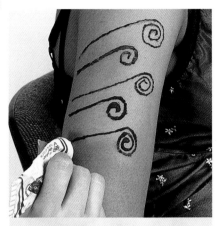

4 Continue down the arm applying scrolls as far as you like.

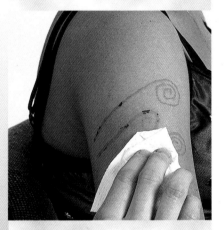

5 Leave for several hours or until the colour darkens. Wipe off henna residue with a damp cloth. These scrolls will fade naturally with time.

Tip
- For finer details use a cocktail or barbecue stick to apply the henna.

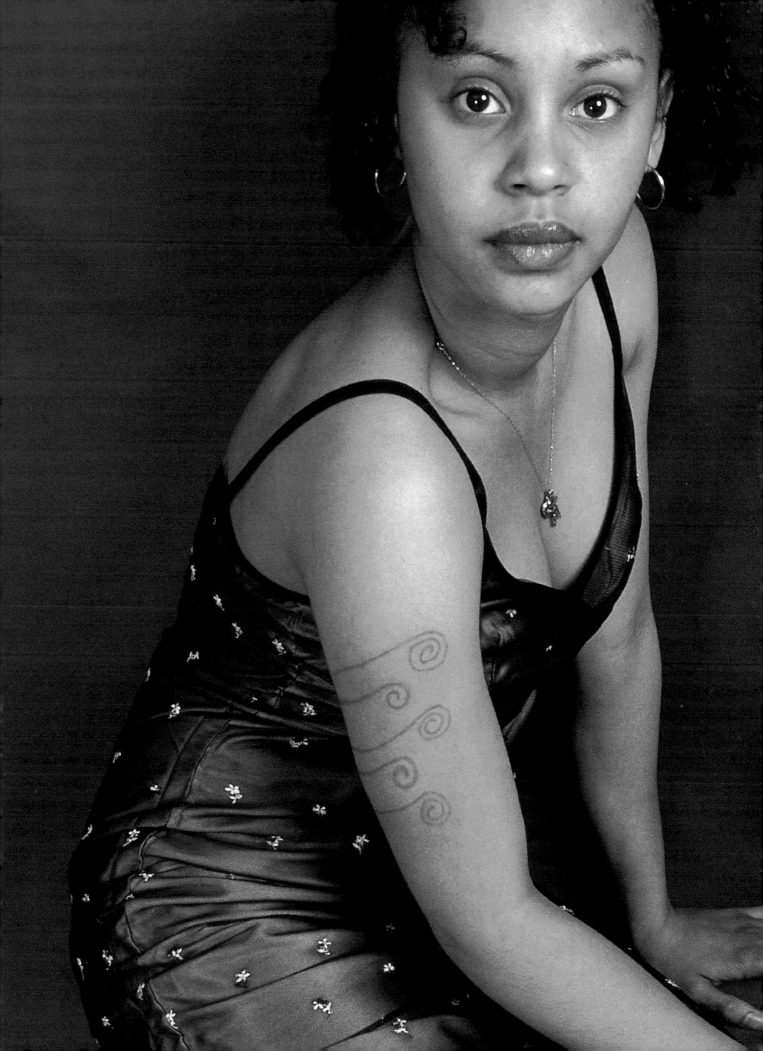

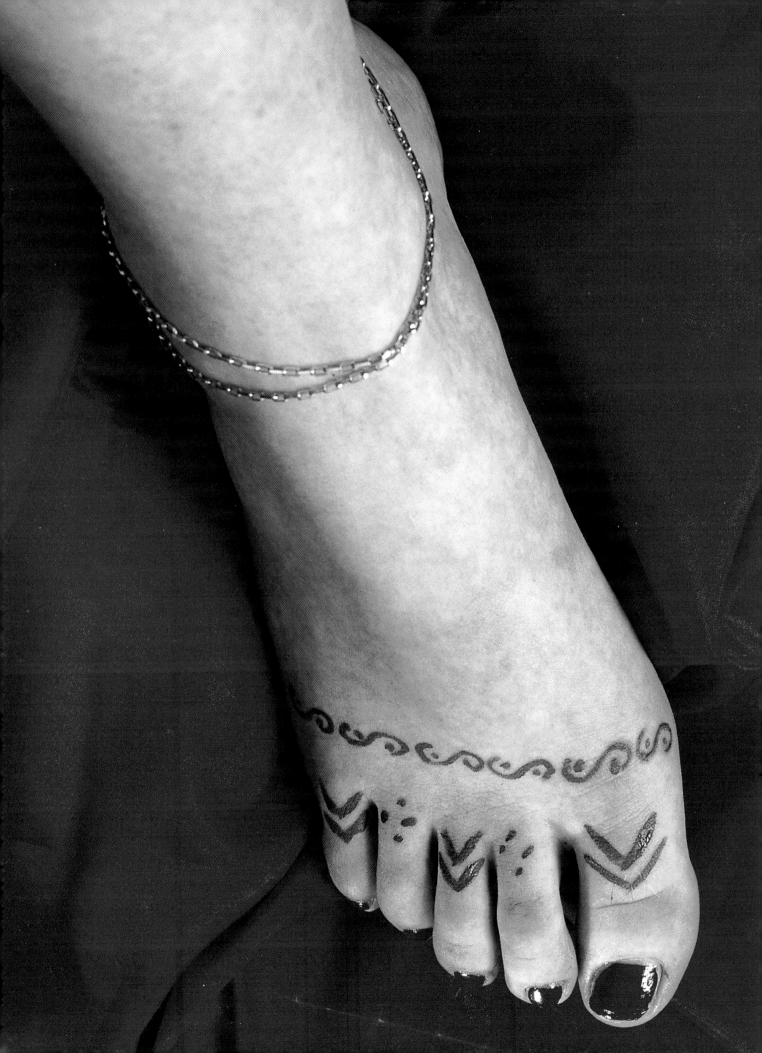

Step ahead

Henna paste can be bought from any beauty shop and is an easy way to apply freehand henna designs. Cut the tip off the nozzle, squeeze gently and apply a thin liquid strand directly onto the skin. There are no rules when applying henna designs, and this freehand method allows you to make up your own patterns.

You will need

- tube of henna paste with a nozzle
- cotton pad
- damp cloth

2 Wash skin area with water and a cotton pad and dry a towel.

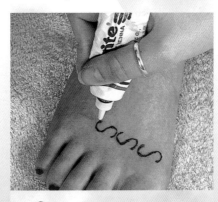

3 Using the paste, draw 's'-shaped waves evenly across the foot.

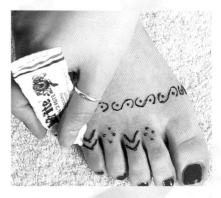

5 Alternating the pattern on each toe, draw two arrows and then a diamond made up of four dots.

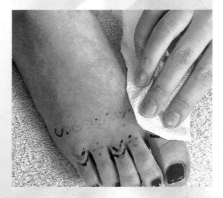

6 Allow the henna to stain for several hours. When the paste is dry, wipe away excess with a damp cloth.

1 Before starting try using the paste on the back of your hand to practice.

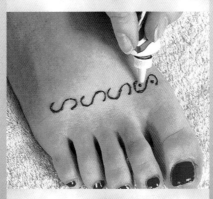

4 Place a small dot in each wave crest pattern.

Tip
- Add lemon juice to the henna to help it stain more effectively.

Ankh cross

There are many different forms of the basic cross shape, like this Ankh cross. Using symbols is a good way of finding inspiration for original designs. Copy simple shapes to start with then progress to more complicated designs as you gain confidence.

You will need
- henna paste
- small brush
- cotton pad

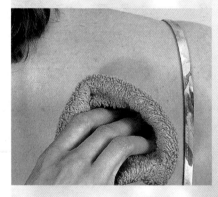

1 Cleanse the area with a cotton pad and water and dry with a towel.

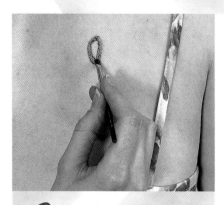

2 Paint a small oval or loop shape on the shoulder blending the centre with a small brush.

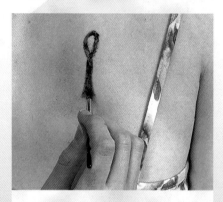

3 Paint the vertical part of the cross.

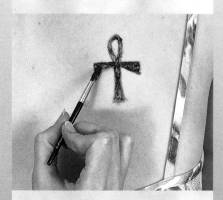

4 Continue by painting a horizontal bar underneath the oval.

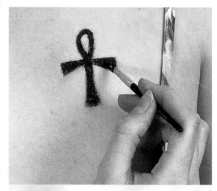

5 Reapply henna paste to fill the design, making sure the skin is well covered with paste. This will help give definition to the design.

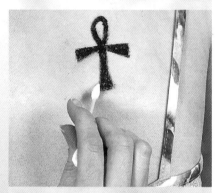

6 Leave for several hours and remove any residue with a cotton pad.

Tip
- After the removal of henna, we enhanced the cross by outlining it with brown tattoo liner.

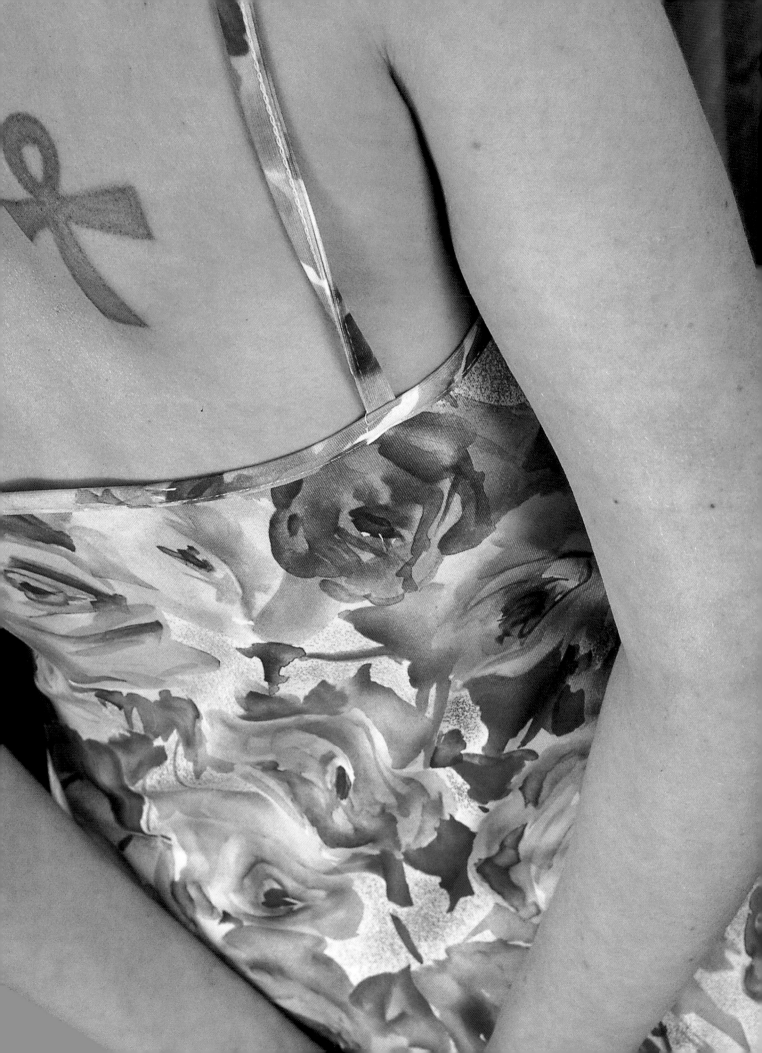

Freehand

Try freehand drawing with henna paste using swirls, lines, dots, circles and squares creating fun and interesting patterns. Find inspiration from Egyptian hieroglyphs, Chinese characters or Greek and Arabic lettering. Their meanings add an element of mystery to the drawing.

You will need

- henna paste
- cocktail stick
- cotton pad

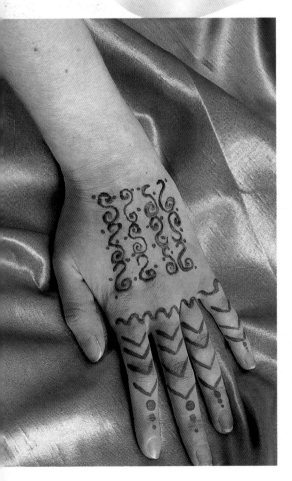

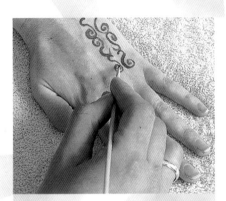

1 Working from the wrist toward the fingers, apply a spiral design with the end of a cocktail stick dipped in henna paste.

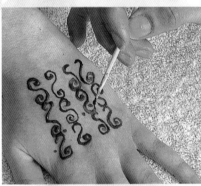

2 Randomly apply dots of the paste with the end of the stick.

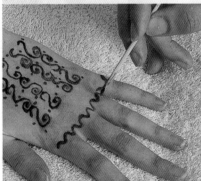

3 Apply wave patterns to the base of the fingers.

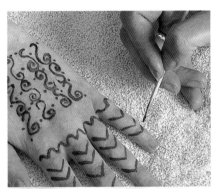

4 Paint 'V' shapes evenly spaced down each finger.

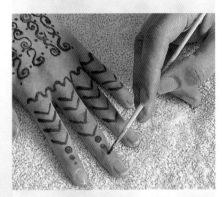

5 Complete the design with a series of small circles graduating towards the end of the fingers.

6 Leave for several hours for the henna to take then remove paste.

Tip

- Stick bindhis onto your design to accentuate the pattern.

3

Make-up

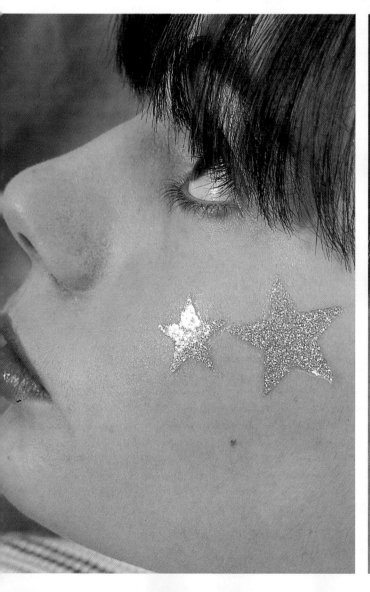

Make-up

Before you start your make-up, decide on the clothes, jewellery and hairstyle that will best complement your appearance. Your choice of make-up has to reflect the style you want to project. Are you dressing for a bold and strident look, or going for a softer, more sensitive one? Remember to cleanse your face and use a toner to remove any cleanser residue.

Moisturise if necessary. Apply a concealer to hide blemishes and dark circles under the eyes. It should be a shade lighter than your foundation. The skin doesn't always need to be covered in foundation, if it is of an even tone without spots and blemishes. Face powder is optional if you want a matt look.

Foundation

Choose foundations that match your skin tone exactly, if it disappears into the skin then it is the right colour match. For black skins choose yellow-based foundations. The undertones of the skin will change in the summer to red or orange, so the foundation undertone will have to be altered to the same tones too. Foundations with a yellow undertone are good for olive and oriental skins, and foundations with blue undertones to pale skins. Apply foundation only on skin where it is needed or high in colour as it is only supposed to even out skin tone and not mask the face. Use your fingertips to blend in the foundation until all areas to be concealed are covered.

Eye shadow

Cream eye shadows can be applied with the fingers, as they tend to seep into make-up brushes. Powdered eye shadows can be applied with disposable make-up applicators or brushes. Powder is simply dusted on with a brush covering the entire eyelid area and blended out.

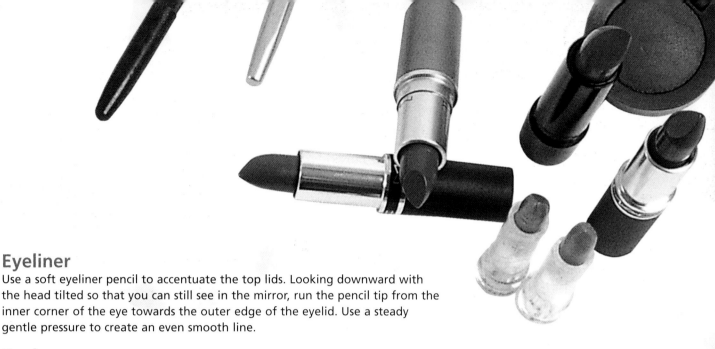

Eyeliner

Use a soft eyeliner pencil to accentuate the top lids. Looking downward with the head tilted so that you can still see in the mirror, run the pencil tip from the inner corner of the eye towards the outer edge of the eyelid. Use a steady gentle pressure to create an even smooth line.

Eyebrows

Use a soft eyebrow pencil the same colour as your eyebrows to enhance their appearance with small gentle strokes.

Mascara

Looking downward, apply mascara in an upward sweeping motion one coat at a time to avoid a sticky build up.

Blusher

Choose a blusher that is as close to natural blush as possible. This will prevent you looking like a China doll.

Lipstick

Outline your lips with a lip liner that is the same or slightly darker in colour than your lipstick. Then fill the lip-line you have just drawn with your chosen colour of lipstick. To make your lipstick last longer and look good blot the lips with a tissue after application and gently apply a little translucent powder on top of the lipstick, then apply second coat of lipstick.

Colour coordination

If you have blonde hair, you can look great during the day wearing rose, apricot, soft-almond and terracotta shades, whilst at night the same colours but a shade more intense with peach and salmon can look stunning. Redheads suit more earth-related colours such as tawny beige, sand, biscuit and copper tones. Electric or petrol blues and pinks look sensational worn at night. Brunettes look good in fresh apricot, pinks and even very strong pinks like raspberry, which can be enhanced for a stunning evening look, but they should avoid mushroom and plum reds.

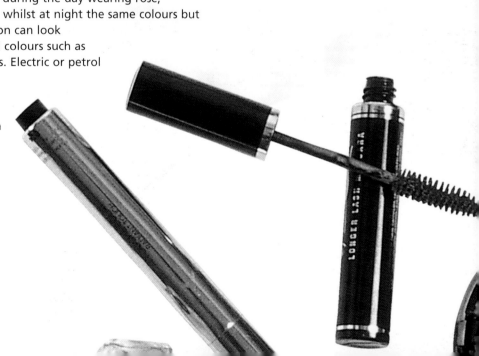

Instant style

Traditionally worn by Indian women, bindhis are a quick and inexpensive way of creating an attractive look for everyday wear or for a special occasion. They can be bought from beauty shops or alternatively you can make your own bindhis from sequins or tiny studs stuck on with eyelash glue.

You will need
- concealer
- foundation
- face powder
- lip gloss
- assorted bindhis

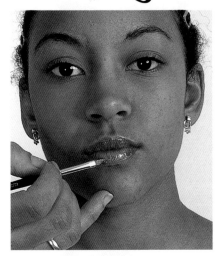

1 Apply make-up and finish look with lip gloss.

3 Bindhis are quick and simple to use and help to create instant style.

Tip
- If you want to be creative you can use body paints and draw your own designs around the bindhi.

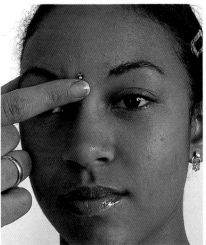

2 Select your bindhi and remove adhesive backing before placing on the forehead between the eyes.

Stuck on you!

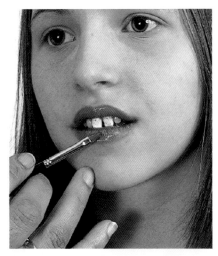

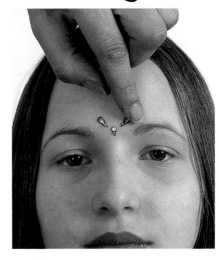

1 Apply make-up and finish off with lip gloss.

3 Continue to apply the bindhis until you have completed your design.

If you are going to use a selection of different bindhis it may be an idea to lay them out first to see if their colour and pattern complement each other. You can also decide on the shape and arrangement before sticking them on to the skin.

You will need
- concealer
- foundation
- face powder
- coloured lip gloss
- lip liner
- coloured bindhis

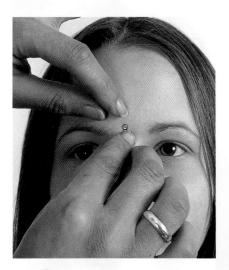

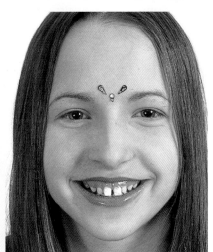

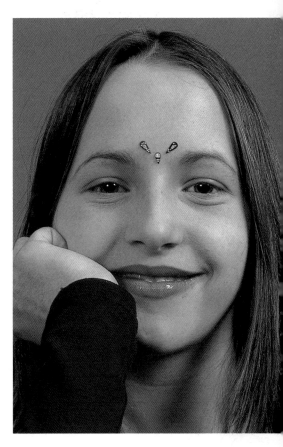

2 Have your design in mind and place the first bindhi in position on the forehead.

4 On this occasion we have arranged them in the shape of a 'V'.

Tip
- Try using sequins or beads as bindhis and adhere with eyelash glue

Star spangled!

Transfers are a quick and easy way to a new look. Used on the hair or face they are an original way to decorate your body. There are many varieties available in matt, glitter or shiny textures.

You will need
- star transfer
- cotton pad and water
- purple eye shadow
- vanilla highlighter
- grey eyeliner
- black mascara
- eye shadow brush
- pink blusher
- blusher brush
- sheer purple lipstick
- lip brush

1 Apply concealer and smooth in foundation.

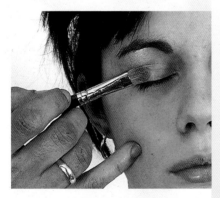

2 Using an eye shadow brush apply purple eye shadow to the lids and blend outward.

3 Apply vanilla highlighter to the brow and define the eyes with grey eye liner.

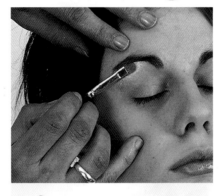

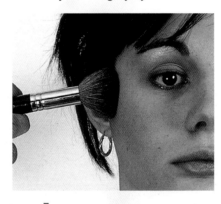

4 Coat the lashes with mascara and brush a little pink blusher across the apples of the cheeks.

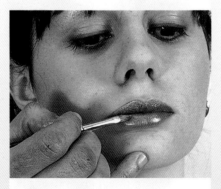

5 Paint the lips with sheer purple lip stick using a small brush.

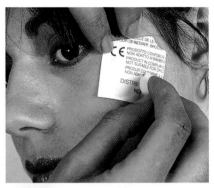

6 Remove the paper and position the transfer, face down, onto the skin. Wet the back and leave for 30 seconds. Remove the backing to reveal the silver star.

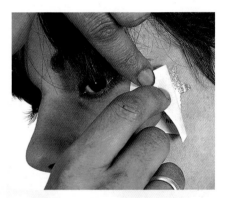

7 Position one transfer on the cheek bone and another to balance the first further down on the cheek.

Tip
- For an evening look enhance the sparkle by sprinkling glitter on to the transfer.

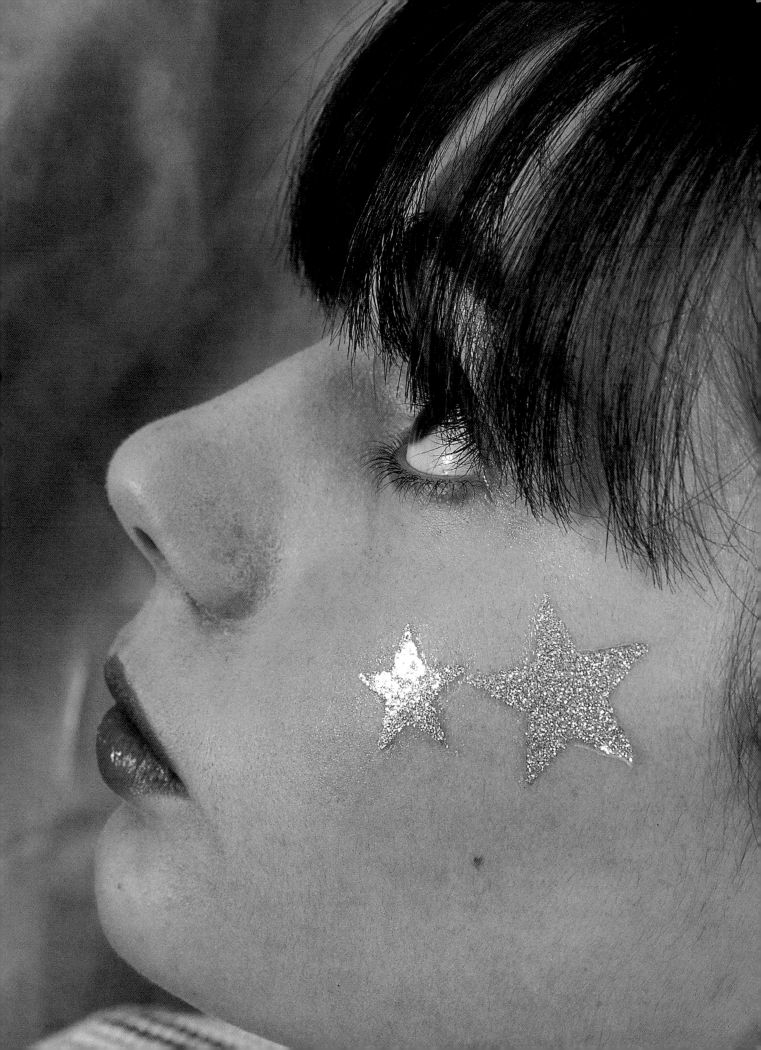

Eye wonder

Beading the eyebrows is an effective beauty technique that can enhance your make-up and your overall look. Use beads that match the size of your eyebrows as they can look out of place if too large. Co-ordinating beads with your outfit or accessories is an excellent final touch.

You will need
- coloured beads
- eye lash glue
- lipstick and lipstick brush
- blush brush
- blusher

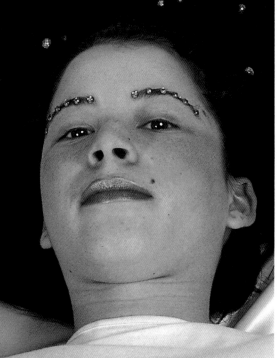

1 Choose a bead and place a little eye lash glue onto the reverse side.

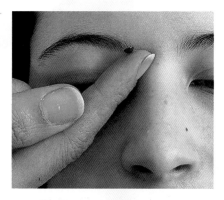

2 Stick the bead onto the inner most part of the eyebrow and press firmly.

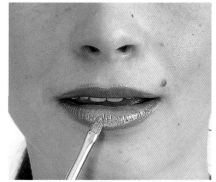

3 Apply alternating coloured beads along the length of the brow.

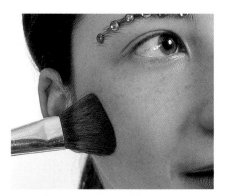

4 Apply your make-up using blusher for definition across the cheeks.

5 Complete the look with a lipstick that complements your chosen colours.

Tip
- Hold the beads between the tips of your finger and thumb when you stick them to your eye brow.

Tears of joy

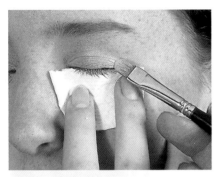

1 Dust the face with translucent powder and apply a lilac eye shadow over three quarters of the lid. Blend in jade green on the remaining eyelid.

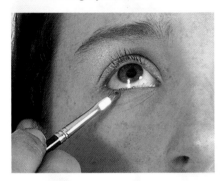

2 Using a soft brush apply a turquoise eye shadow to the lower inner corner of the eyes. Complete the lid using purple eye shadow.

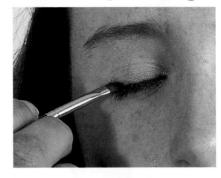

3 Apply green eye liner above the lashes before putting on the mascara.

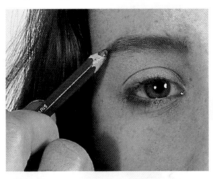

4 Use a taupe eye brow pencil to define the eye brows then add pink blusher to the cheeks. Add lipstick.

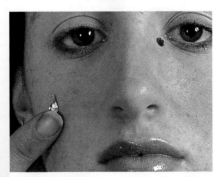

5 Put a little eye lash glue on the reverse side of the bead and place it inside the bridge of the nose next to the eye. Take a tear drop bead and adhere to the cheek.

Getting ready for a night out can be such fun, so why not add to the glamour by using a tear-drop bead with your make-up. Small semi-precious stones have beautiful colours and patterns that sparkle in the light.

You will need
- tear drop beads
- eye lash glue
- lilac, jade green, turquoise and purple eye shadow
- green eye liner
- small brush
- taupe eye brow pencil
- black mascara
- pink blusher
- larger blusher brush
- purple lipstick

Tip
- To create your own lipstick use eye shadow mixed with a little petroleum jelly.

Glam glitter

This stunning glitter look is ideal for when you really what to make an impact. Stun your friends with this fabulously glamourous look. So, don't hold back, this is your chance to really go wild!

You will need

- concealer
- foundation
- pink opal pigment highlighter
- eye shadow brush
- blue liquid eyeliner
- turquoise eyeliner pencil
- blending brush
- black mascara
- grey eye shadow
- brow brush
- pink luminiser stick
- bronze luminiser stick
- glitter and glitter stars
- petroleum jelly

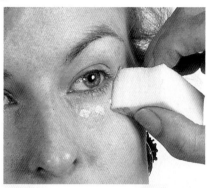

1 Apply concealer and then foundation using a sponge or fingers and blend in evenly over the skin.

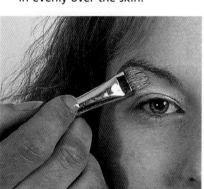

2 Apply pink opal pigment on the eyelid and brow.

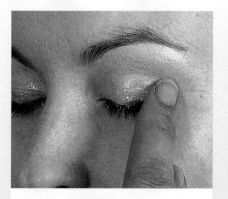

3 Stick a little glitter to the eye lids by first applying petroleum jelly.

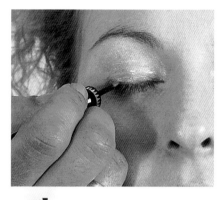

4 Use turquoise liner above the eye and blue underneath. Apply mascara.

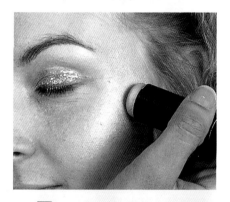

5 Define your eye brows with grey eye shadow, then add pink and bronze luminiser to the cheek bones.

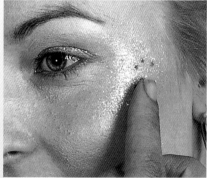

6 Adhere the glitter stars to the cheeks with a little more petroleum jelly.

7 Finish off the lips with a little iridescent glitter over the gloss.

Tips
• Use the bronze luminiser to highlight the cheekbones giving them more definition. Alternatively use petroleum jelly for a similar effect.

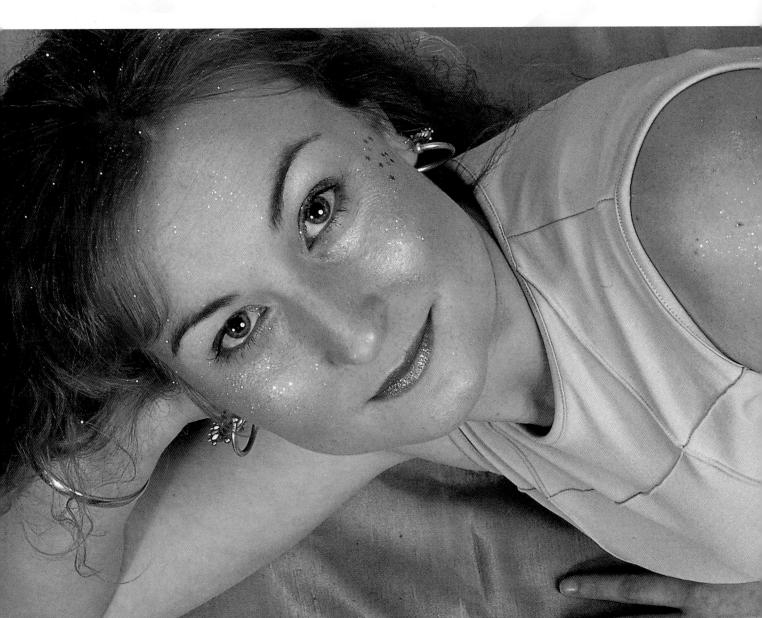

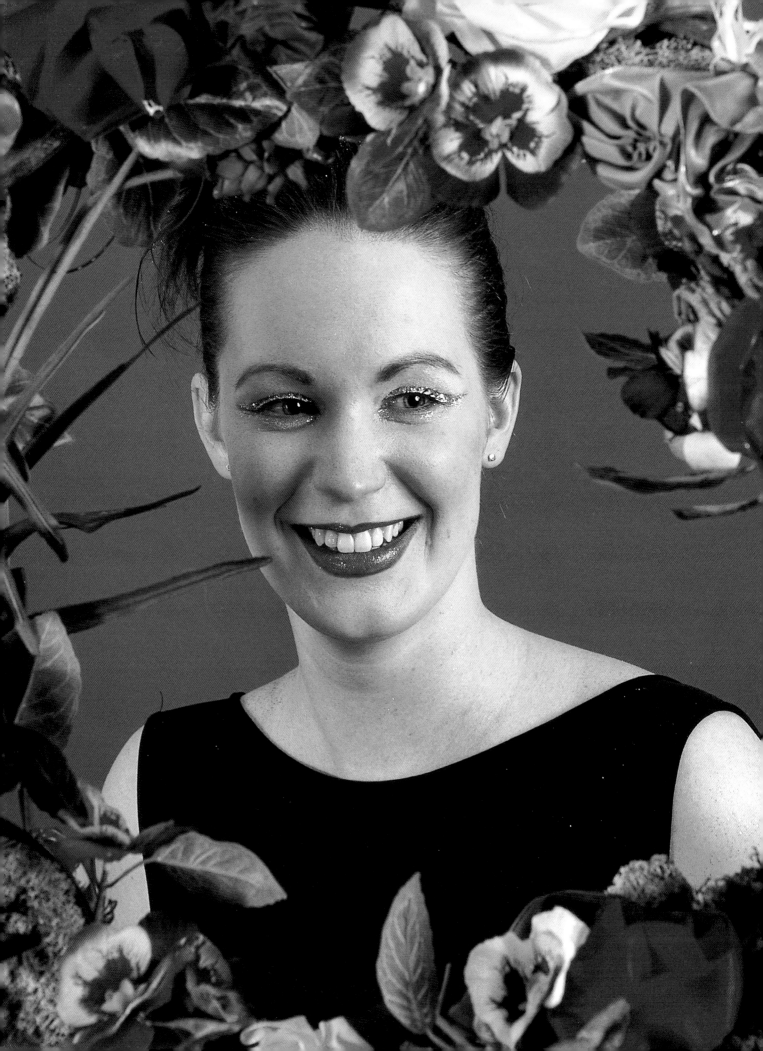

Retro sparkle

Enjoy a '70s disco revival. This glitter make-up will take about 15 to 20 minutes to create. If you don't have any of the items listed below, try developing your own glitter look using shiny and glittery products that you already have in your make-up collection. As the theme is glitter, any sparkly make-up products you have can be used, however always remember to follow manufacturers guidelines.

You will need
- translucent powder
- large blending brush
- glitter eye decorations
- iridescent vanilla pigment
- bronze eyebrow pencil
- mascara
- pink iridescent pigment
- fuchsia lip liner
- petroleum jelly
- glitter

Tip
- Look out for multi-purpose products on the market that can be used as eye shadow, blusher and lipstick to save you money.

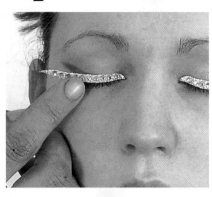

1 Adhere the sticky backed eye decorations just above the lashes.

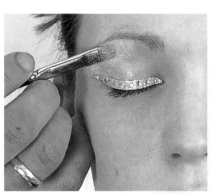

2 Use the iridescent vanilla pigment to highlight the eye and brow area.

3 Apply eyebrow pencil and blend. Use pink iridescent powder underneath the eyes and on the cheeks.

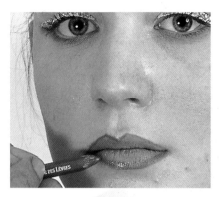

4 Define the eyes with mascara and lips with pink fuchsia lip liner.

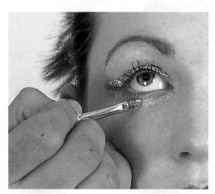

5 Apply eye glitter with a small brush.

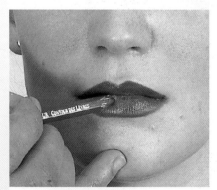

6 Apply the lip colour and finish with glitter using a brush.

Shine on

This shiny look can be worn on its own or with your normal eye shadows and mascaras. It will give you a fresh, natural and healthy looking glow and is a good example of 'less is more'.

You will need
- concealer
- luminising stick blusher
- foundation
- shimmering eye shadow
- sponge
- tawny-brown eyebrow pencil
- all-over face glow
- pearl eye shadow stick
- blending brush
- green eyeliner pencil
- lip brush
- charcoal grey eyeliner
- lip gloss

Tip
- Choose your foundation to match the colour of your neck and select a concealer one shade lighter than your foundation.

1 Apply face glow evenly onto the base make-up using your finger tip. Add shimmering eye shadow to the eye lids.

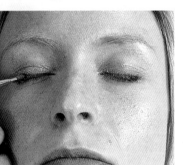

2 Use a thin line of charcoal grey eyeliner above the lashes and smudge.

3 Apply pearl eye shadow to the inner part of the lower lid and then dark green eye shadow to the lid.

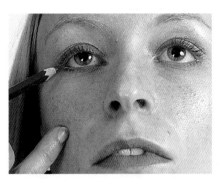

4 Use dark green eyeliner under the eyes then add the mascara.

5 Apply tawny brown pencil to the eyebrow and then luminising blusher on the cheeks.

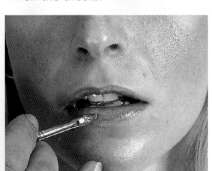

6 Apply lip gloss and smooth out with lip brush or finger tips.

Au naturel

Natural make-up can look sensational on its own or become the basis for a more adventurous image. It is subtle and easy to create for everyday wear. The colours are neutral so you don't need to worry about colour co-ordination with clothing and accessories.

You will need

- peach eye shadow
- bronze eyebrow pencil
- black mascara
- peach blusher
- blusher brush
- spice lip pencil
- petroleum jelly

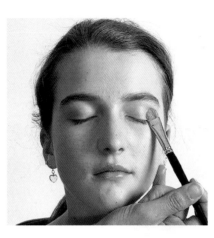

1 Brush peach eye shadow onto the eyelid. Define eyebrows with bronze pencil.

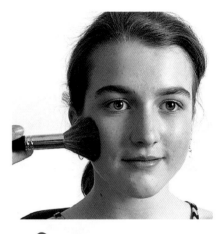

3 Add peach blusher to the cheeks, blending out towards the temples.

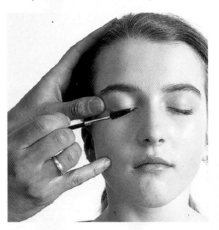

2 Closing your eyes, brush a black mascara wand away from the eyelid to achieve a natural effect.

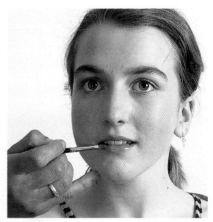

4 Outline the lip with a spice lip pencil, and use a brush to apply a little petroleum jelly.

Tip

- Good eye colours to use include browns, mushrooms, creams, peachy colours and for darker skins deeper browns, terracottas and bronzes.

Hair decorating

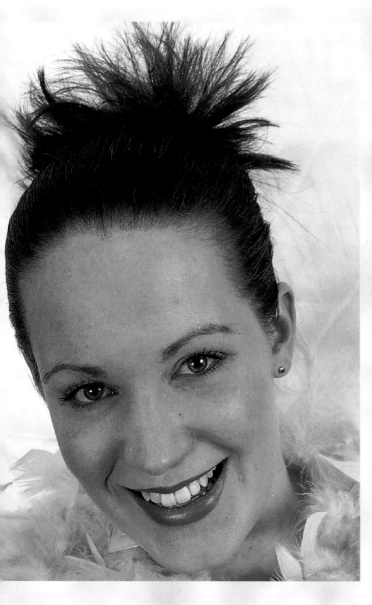

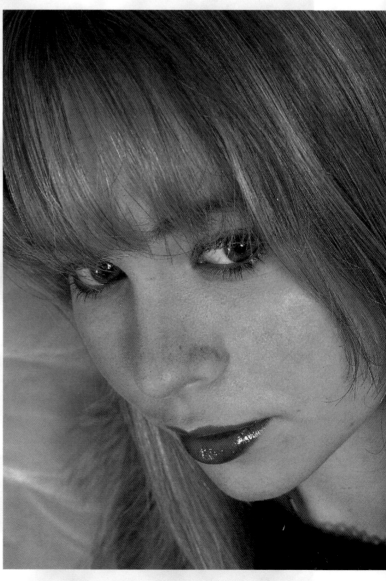

Hair decoration

There is a wild and wonderful variety of accessories to decorate your hair, ranging from grips and bands to feathers and chopsticks. Hair slides come in a number of different designs and are easy to use along with hair grips and bands. Keeping hair in place or out of the way is the role of these accessories. They may appear simple but chosen to go with your outfit and make-up, they can add that special finishing touch to your appearance.

No dressing table is complete without a good hairbrush and comb. A wide-toothed comb is ideal along with a brush, preferably one with rounded bristles, which will help to massage the scalp and prevent scratches and abrasions.

Decorative hair products are numerous and the range is constantly growing, as this is an expanding and developing market. You can now easily purchase glitter sprays, coloured mousses, gels, sprays, pomades and mascaras - they all await your pleasure. These hair products used singly or in combination can help you create an individual look. Simply stroll along the hair-care products of your local pharmacist or beauty-care shop and you will be spoilt for choice. It helps if you have an idea of what you wish to create first before shopping, so that you only come back with items that you really want and are going to enjoy using.

Hair decorating

Hair attachments and hair adornments are two methods of decorating your hair. Attachments come as either hair binding or weaving. Hair binding uses synthetic or real hair and can be used to add body, length, and colour. Weaving and

braiding also use synthetic and real hair in slightly different ways. Weaving involves sewing hairpieces into hair that has been plaited as close to the scalp as possible. Braiding is simply plaiting hair and can involve three or more strands. A further development of braiding is 'corn row' which offers the opportunity to create even more elaborate hairstyles. It is another plaiting technique and is distinguished by tight plaits created in rows close to the scalp. Hair adornment covers everything that is used to decorate the hair and includes stencils, coloured hair mousse, glitter, hair mascara and ribbons, feathers, beads, hair grips, clamps and chop sticks.

Crimping

Crimping irons are used to add texture and body to hair and to give straight hair a tight wave. To remove crimp simply wash your hair.

Straightening

If you wish to achieve a sleek straight look you can use hair straighteners. These straightening irons have the opposite action to crimping and remove waves and kinks from hair. Straightened hair will revert back to its previous shape if it becomes wet or if the atmosphere becomes humid.

Hair gels

If you wish to create a sleek 1920s look, hair gels are ideal. Dampen the hair and comb through with a wide-toothed comb to remove knots and tangles. Then apply hair gel to the entire head of hair and comb through to your desired sleek style. You can incorporate hair partings or slick the hair right back. Hair gels come in the form of hard setting, wet and normal hold preparations. To jazz up your gels try adding glitter and coloured pigment.

Pomades

These are used to sculpt the hair and create dramatic finished looks in hair fashion. Pomade is excellent for use on naturally curly or permed hair and helps to manage the hair and give texture and shine.

Hair gloss

This is a wonderfully smooth product that will finish your hairstyle with shine without unwanted heaviness or oiliness.

Hair spray

This is used to hold your hairstyle and comes in normal, medium and strong hold. A fine mist will help set the hair in place.

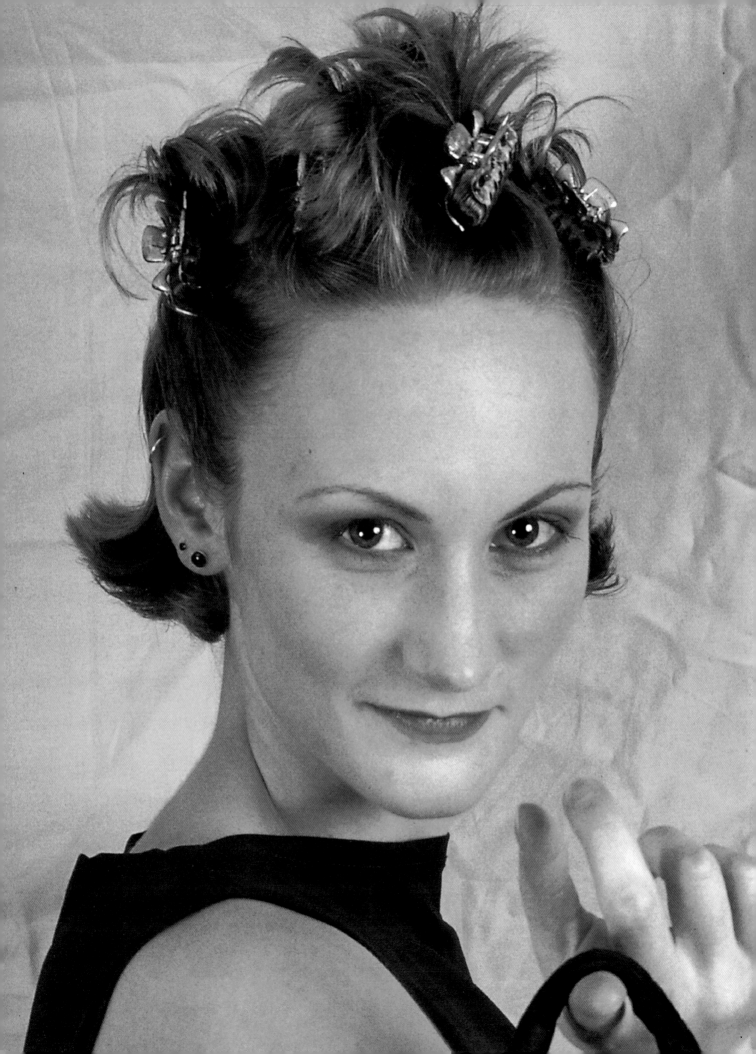

Get a grip!

Hair accessories can be great fun. If your hair can be tied, clipped or gripped in place then an accessory can really add a delightful touch to your look. There are a wide variety of clips, slides and ties available in the shops and you can even try making your own. Create beautiful accessories by covering a band in pretty fabric or dressing a clip with trinkets and novelties. Try this on long or short hair.

You will need
- comb
- hair pomade
- butterfly clips

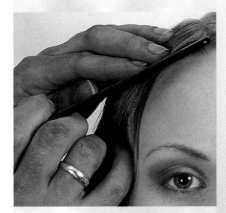

1 Apply hair pomade and comb hair to remove tangles. Pomade will also give shine to dull hair and seal split ends.

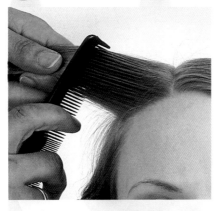

2 Create an off centre parting. Starting from the parting and working outward divide the front of the hair into four separate sections.

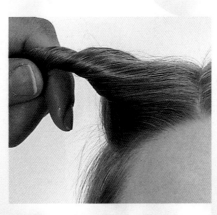

3 Gather the hair in one section and twist until it twists back on itself firmly in position.

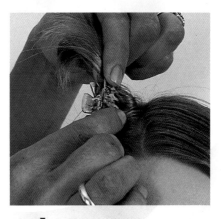

4 Hold in place with a butterfly clip.

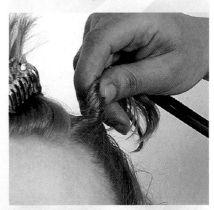

5 Continue taking sections of hair, twisting and clipping the hair in place.

Tip
- For a longer lasting look hold the hair using a strong hairspray.

Light as a feather

This hair design is easily done with long hair. The hair is twisted and clipped up into place and then the ends are spiked. Try varying the lengths of the hair spikes.

You will need

- comb
- hair pomade
- hair band
- hair spray (strong hold)

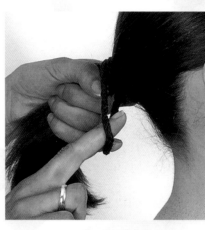

1 Apply hair pomade and brush hair thoroughly removing tangles and knots. Comb hair into a pony tail and secure using a hair band.

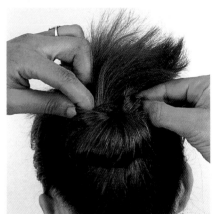

3 Fan the base of the pony tail to conceal the hair band. Twist the tail around and secure against the head with the ends standing up.

2 Fold the tail onto itself and pull the base of the ponytail back through the hair band.

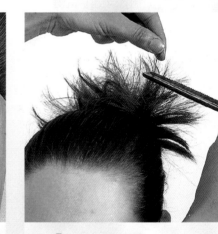

4 Gently backcomb the ends of the hair creating the spiky effect. Use hair spray for a stronger hold.

Tip
- Put glitter or coloured hair spray on the ends of the hair for a more dramatic look.

Funky plaits

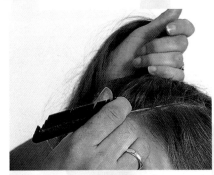

1 Brush the hair piece with a wide toothed comb. Divide hair into sections and condition the hair before adding the hair piece.

3 Cut the hair piece to match you own hair length then section your hair near the roots so you are ready for plaiting.

Plaits are fun and easy to do. Hairpieces are readily available from department stores and specialist hair suppliers and they can be an exciting way to transform your hair for a day. Colours close to your own natural hair colour will produce a subtle look, whereas a contrasting colour is more dramatic for a special occasion.

You will need
- hair piece with woven edge
- wide-toothed comb
- tail comb
- hair clips
- hair bands
- scissors
- mousse/leave-in conditioner

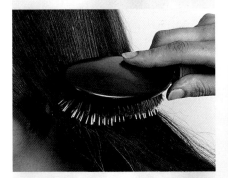

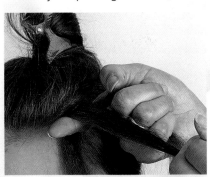

2 Brush your hair through making sure you remove all the knots and tangles.

4 Divide the sections into two and plait in the hair piece making three strands to plait in total.

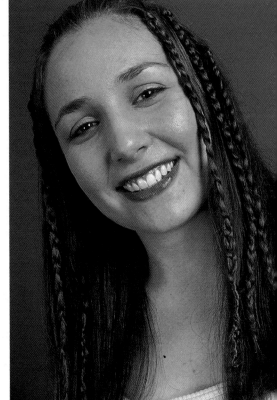

Tip
- Add colour and texture by plaiting strips of material into your hair.

5 Continue plaiting to the hair ends. Fasten by wrapping any remaining hair around the bottom.

Streaks ahead!

Hair mascara is available at most make-up counters and shops selling hair-care products. This technique is effective if you use a colour that matches the rest of your make-up and clothing. Try using a hair mascara containing UV or luminescent paint and see it glow and shine in a night club. It is quick and easy to use and will vanish in a single wash.

You will need

- comb
- hair mascara

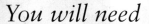

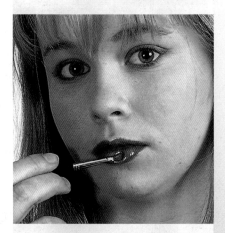

1 Finish applying your make-up before applying the hair mascara.

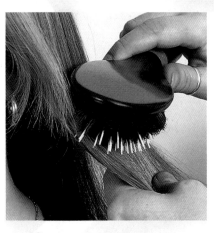

2 Brush out your hair to remove all tangles.

3 Selecting small sections of hair start to apply the mascara evenly.

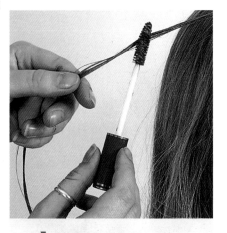

4 For our model we used blue hair mascara, starting at the roots and coating the hair to the tip.

5 The look was finished using both blue and purple mascara.

Tip

- Use two colours on the same strand of hair, one starting at the root toward the middle and the other continuing to the end.

The mane act

This takes a little time to do, about half an hour. The more hair you have the longer it will take. However, the effect is great and well worth spending the time on for a very unique look that will last until washed.

You will need
- hair pomade
- crimping irons
- beaded hair comb
- hair clips
- glitter
- hair spray
- lip gloss

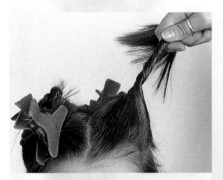

1 Brush the hair then part evenly around the crown of the head, twist and clip out of the way.

Tip
- Place a comb under the crimpers to protect your head from the heat.

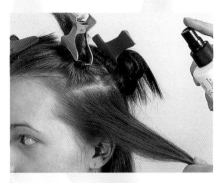

2 Section hair to the width of your crimpers and apply a medium to strong hold hair spray or spritzer.

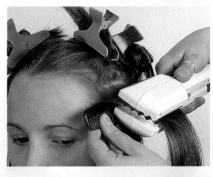

3 Crimp the section of hair close to the roots holding the crimpers in place for a few seconds.

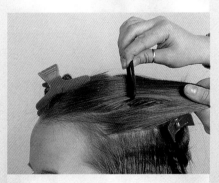

4 Part the hair that was clipped at the top of the head into sections ready for crimping.

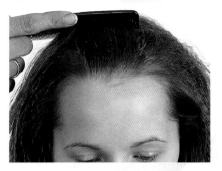

5 Work across the head until all the hair is crimped then carefully comb the hair to remove the parting.

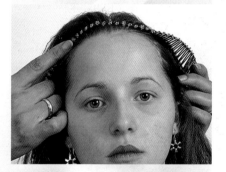

6 Position a beaded hair comb by drawing it across the top of the head to hold the hair in place. Sprinkle hair with glitter.

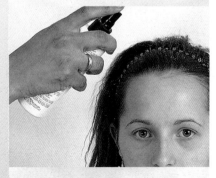

7 Set the glitter in your hair using hair spray. To complete the look apply lip gloss to the lips.

Tail feathers

There are a wide variety of hair extensions on the market today. The beauty of them is that you can have several different looks without cutting or dyeing your hair.

You will need
- clip on hair extension
- coloured lip gloss
- hair pomade
- hair bands
- hair brush and comb

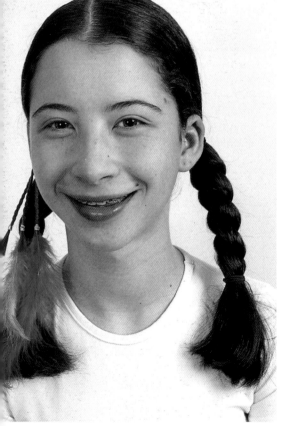

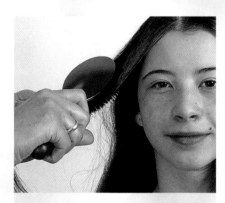

1 Brush hair through to remove tangles. Use a little hair pomade to smooth out and give shine to the hair.

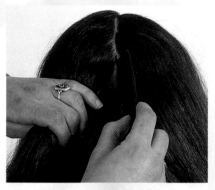

2 Part the hair in the centre all the way to the nape of the neck.

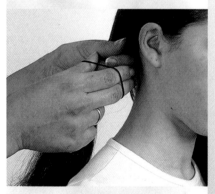

3 Gather the hair together to make two ponytails.

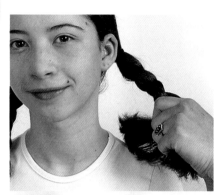

4 Part each ponytail in three sections and then plait together. Secure the ends with a hair band.

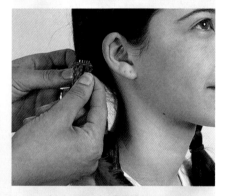

5 Thread the hair piece into the back of the plait. You may secure it with hair grips hidden in the plait.

Tip
- Look around your home for ideas and items for decorating your hair.

Fringe benefits

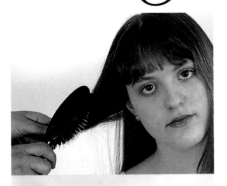

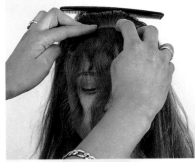

L iven up your hair style with a colourful hair piece or hair extension. Using a non-toxic, temporary glue, hair pieces are easy to attach and will give the effect of layers of colour through your hair.

You will need
- hair piece
- bonding glue
- scissors
- hair brush and comb

1 Brush the hair removing all tangles and knots.

3 Apply bonding glue to the hair piece. Position the hair piece, glue side down, on the hairline of the fringe and press in place.

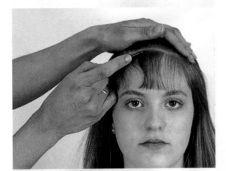

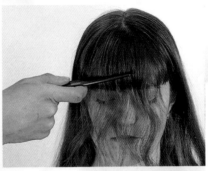

2 Select your hair piece and cut to the width of your forehead. Comb back the majority of the hair leaving some of the fringe at the front.

4 Comb the fringe back over the hair extension to blend them together.

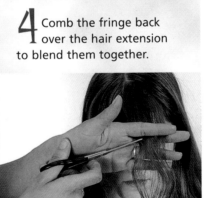

Tip
- Try combining hair pieces and extensions with coloured hair mascara.

5 Trim the hair extension to the same length as the fringe. Feather sections of the hair piece through the fringe for the colour to show.

Twist and shout

This hair design is sometimes referred to as hair winding. It is an easy style to create and fun to wear. If your hair is secured it will stay in place for a couple of days. At night wear a headscarf for extra protection so that the hair stays in place.

You will need
- hair pomade
- hair accessories
- hair grips
- hair comb

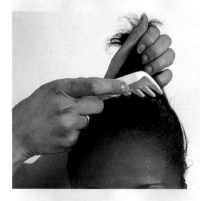

1 Apply hair pomade and comb through to the ends. Make sure you remove all tangles.

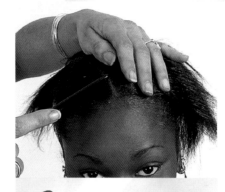

2 Decide where you want your partings, Part the hair using the end of a comb.

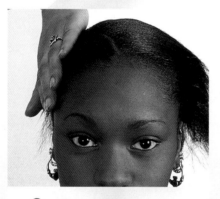

3 Smooth the hair down on either side.

4 Evenly section small amounts of hair and twist two strands of hair tightly until they twist back on themselves.

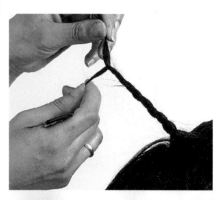

5 Continue dividing the hair into sections and twist. Try and balance the number and size of your hair sections for an even look.

6 Attach small, brightly coloured hair clips to the hair to finish it off.

Tip
- For European hair the twists may come undone so secure with a hairgrip or small hair band.

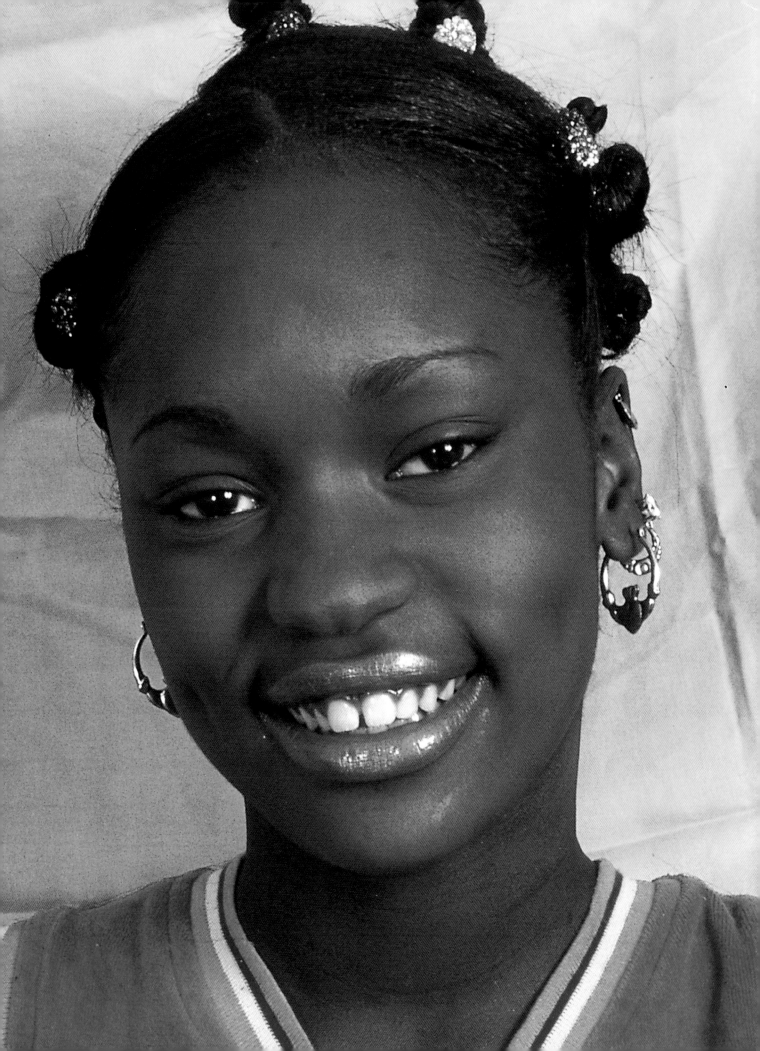

Heart and soul

These colourful hair transfers come in a variety of different finishes. The glitter transfers are particularly attractive and look fabulous under UV party lights. Straight hair is ideal for this hair decoration as it holds the shape.

You will need
- hair transfers
- small bowl of water and a sponge
- medium hold hair spray

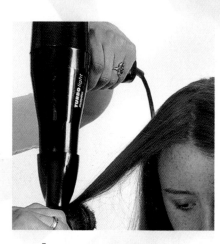

1 Wet hair down and comb through with sculpting spray, then blow dry hair into a straight style.

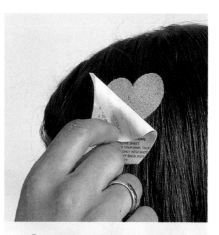

3 Gently peel off the backing paper.

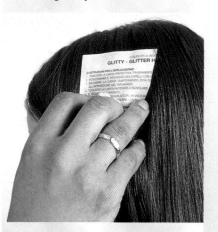

2 Position the transfer face down onto the hair then wet the backing paper liberally with water using a small sponge.

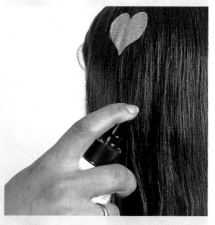

4 Allow to dry and then use hair spray around the transfer to prevent flyaway strands of hair.

Tip
- Always use a conditioner to protect the hair from heat damage.

Jewellery

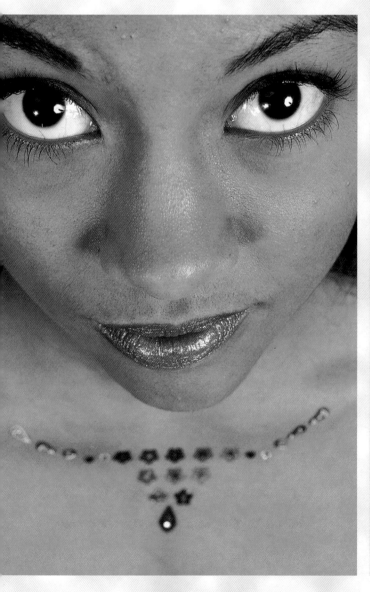

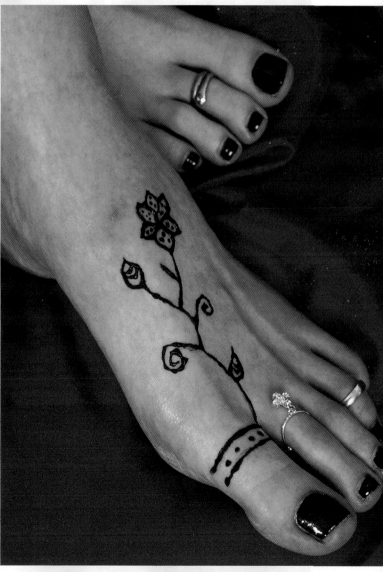

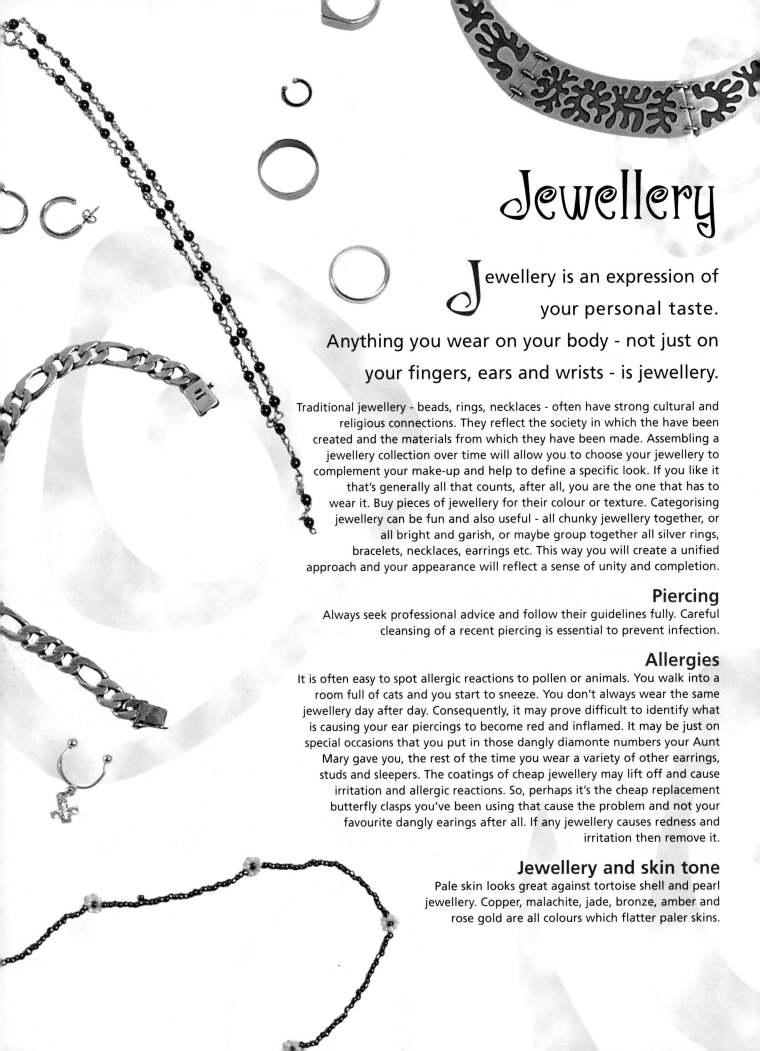

Jewellery

Jewellery is an expression of your personal taste. Anything you wear on your body - not just on your fingers, ears and wrists - is jewellery.

Traditional jewellery - beads, rings, necklaces - often have strong cultural and religious connections. They reflect the society in which the have been created and the materials from which they have been made. Assembling a jewellery collection over time will allow you to choose your jewellery to complement your make-up and help to define a specific look. If you like it that's generally all that counts, after all, you are the one that has to wear it. Buy pieces of jewellery for their colour or texture. Categorising jewellery can be fun and also useful - all chunky jewellery together, or all bright and garish, or maybe group together all silver rings, bracelets, necklaces, earrings etc. This way you will create a unified approach and your appearance will reflect a sense of unity and completion.

Piercing

Always seek professional advice and follow their guidelines fully. Careful cleansing of a recent piercing is essential to prevent infection.

Allergies

It is often easy to spot allergic reactions to pollen or animals. You walk into a room full of cats and you start to sneeze. You don't always wear the same jewellery day after day. Consequently, it may prove difficult to identify what is causing your ear piercings to become red and inflamed. It may be just on special occasions that you put in those dangly diamonte numbers your Aunt Mary gave you, the rest of the time you wear a variety of other earrings, studs and sleepers. The coatings of cheap jewellery may lift off and cause irritation and allergic reactions. So, perhaps it's the cheap replacement butterfly clasps you've been using that cause the problem and not your favourite dangly earings after all. If any jewellery causes redness and irritation then remove it.

Jewellery and skin tone

Pale skin looks great against tortoise shell and pearl jewellery. Copper, malachite, jade, bronze, amber and rose gold are all colours which flatter paler skins.

If you don't want to pierce your skin and
still wish to wear earrings or belly-button rings
for their look then don't despair. Clip-on jewellery is now widely available
and can look just as authentic and effective without the pain. For a personal
touch, if you are wary of piercing, try creating your own jewellery. Use stick-
on beads, transfers, and stencils, or try painting on jewellery using tattoo
paints. With a little eyelash glue, beautiful beading effects can be created
by sticking individual beads on to the skin which will last all night long
whilst you're partying.

Complementing

When choosing coloured jewellery take into
consideration the colour of your eyes. Well-
chosen pieces such as earrings or a necklace
selected for their brilliance and tone can
enhance your eye colour and with the right
make-up will turn heads in your direction.
Amethyst will highlight blue eyes and bring out
their colour. Tigers eye will complement hazel and brown eyes whilst amber
stones work well against green eye colour tones. Also think of hair colour,
for example, jade jewellery looks wonderful against auburn hair.

Face shape

Your face shape may also determine the type of jewellery that suits you best.
Some people know instinctively what suits them, but if in doubt, hold pieces
against your skin to gauge their effect. Small earrings and studs easily flatter
petite features, whereas huge hoop earrings may look out of place and
frankly ridiculous. On tapered features with an elegant neck, drop earrings
look simply spectacular.

Taste and confidence

Having said all this, jewellery is very much a personal issue and no one has to
wear it if they don't want to and if they do it's up to them what they
wear. So, if you are truly comfortable with yourself, your jewellery, make-
up, clothes and the image you present to the world, then you will
naturally shine and your confidence will be an example and source of
admiration to all and then your inner beauty will also be visible.

Cleaning jewellery

Silver jewellery should be cleaned using silver cleaner. It comes as immersing
liquid or impregnated cotton wadding. Dip jewellery into the liquid for a
few seconds or wipe with wadding. Buff jewellery with
soft tissues or cotton pads to bring back their lustre.
Beads and glass can be wiped with a soapy cloth to
remove oil and dirt residue and buffed up with a
polishing cloth.

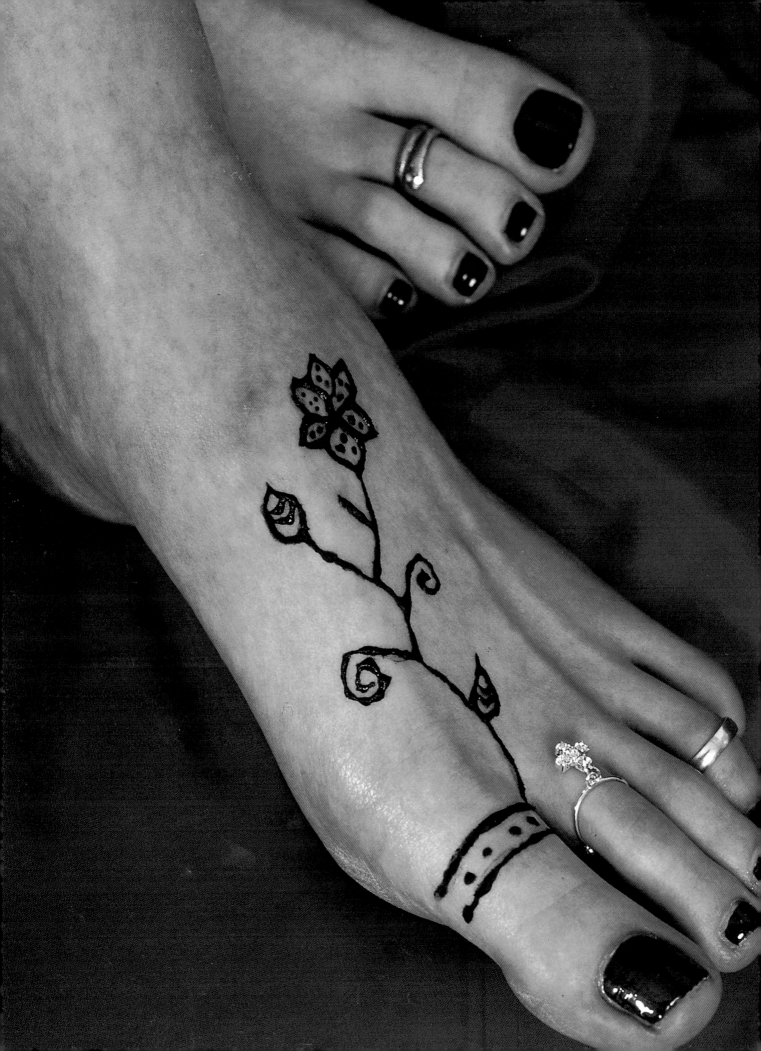

Toe-tally cool

Toe rings are another form of body adornment and can look lovely with open-toe sandals in the summer. Before applying the henna prepare your feet with a manicure and paint the nails in your favourite colour.

You will need
- cotton pads
- nail varnish
- hairpin or cocktail stick
- henna mix

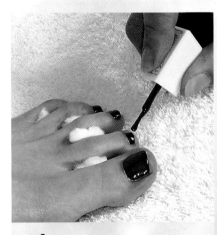

1 Place cotton pads between the toes and paint the toe nails with two coats of nail varnish.

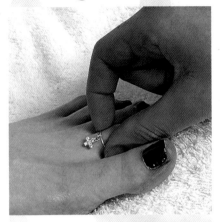

2 Slide your toe rings into place on your toes.

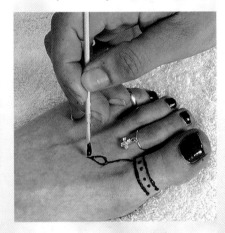

3 Using the point of a cocktail stick dipped in henna paste start by drawing a double ring around the big toe and fill with dots.

Tip
- Put cotton pads between the toes to prevent them from overlapping.

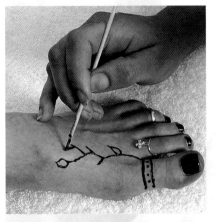

4 Leading from the toe toward the ankle draw a wavy line to represent the stem of the flower.

5 Paint six petals of the flower and then fill in with a random pattern.

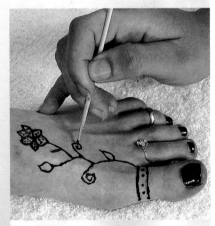

6 Paint the leaves, some in the traditional leaf shape and others as scrolls.

Beaded necklace

To create this stunning effect, transfers, bindhis and beads were used. Arranged simply around the neckline this technique is simple to do and yet so original. Apply after you have completed your make-up and chosen your clothes for the occasion.

You will need
- beads
- bindhis
- glitter transfer
- scissors
- water and small sponge
- small bowl of water

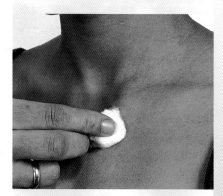

1 Cleanse the area where you are going to apply the necklace.

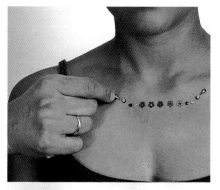

2 Cut out the transfer that you are going to use and place face down before soaking in water to stick to the skin.

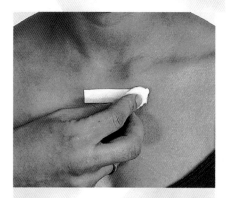

3 After a few seconds carefully peel off the back of the transfer.

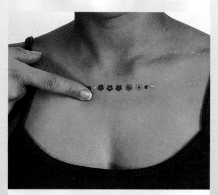

4 Stick two beads either side of the ends of the transfer tattoo.

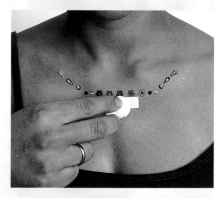

5 Stick bindhis either side of the beads.

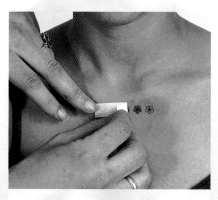

6 Cut a smaller strip of transfer tattoo and wet as before. Apply the reverse side just under the centre of the design.

7 Repeat step 6 with a smaller part of transfer making a triangle design.

Tip
- Although the beads may come with a sticky back it may be necessary to use a little eye lash glue if they lose their stickiness

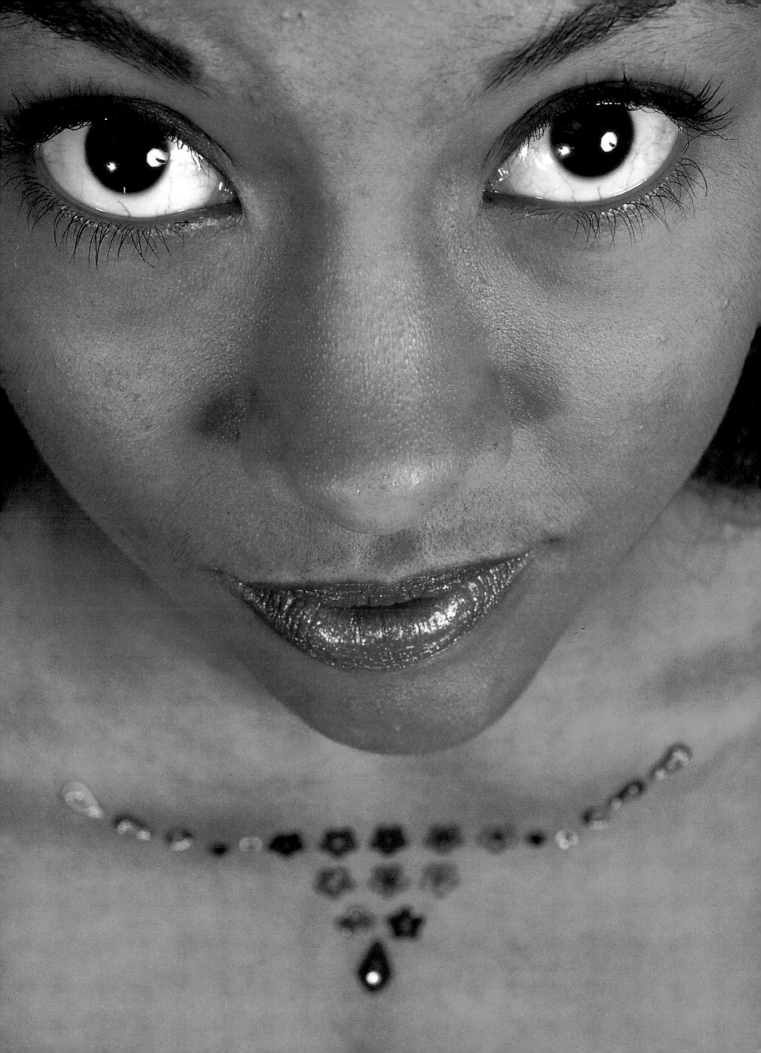

Floral swirl

Decorating your stomach with body art is an exciting alternative to piercing. Use paints, transfers or stick-on tattoos to highlight the belly-button area. By combining with piercings and clip-on belly rings you can completely transform the look of your stomach.

You will need

- clip-on belly button ring
- red Kum Kum paint
- red bead
- tear-drop beads
- eyelash glue
- small brush or applicator

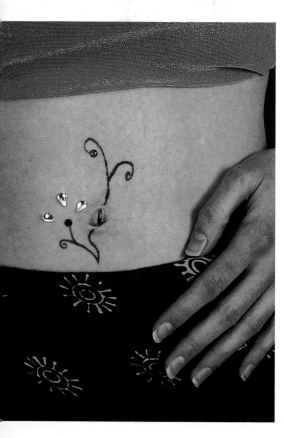

1 Position your clip-on belly button ring.

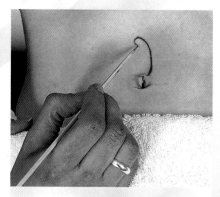

2 With steady even strokes paint a tendril upwards using red Kum Kum paint.

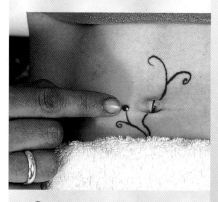

3 Place a small drop of non-toxic spirit gum or eyelash glue on the back of a red bead and position at the end of the painted tendrils.

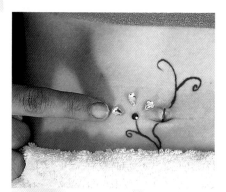

4 Position and stick three tear drop beads around one of the red beads forming petals to the design.

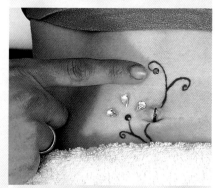

5 Position and glue in place a small green bead on the end of one of the other painted tendrils.

6

Nail Art

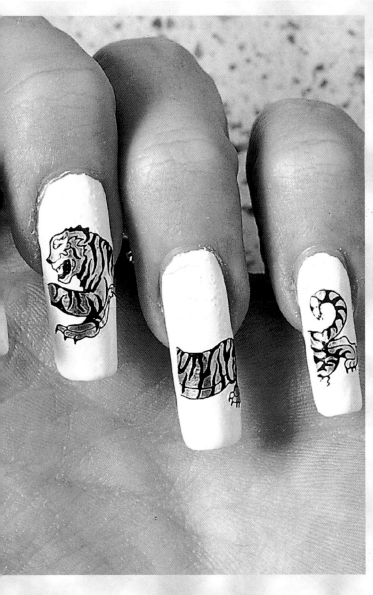

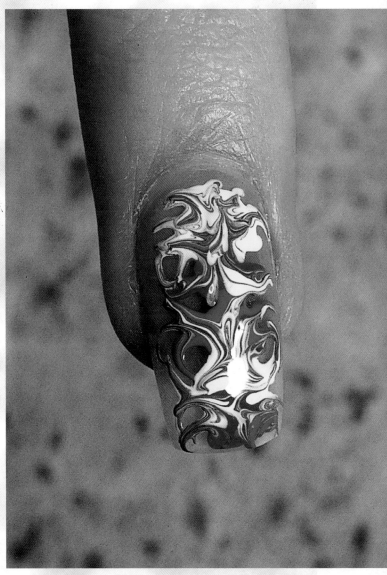

Nail art

Well-manicured nails flatter the wearer and are a joy to look at and touch. They accentuate your hand movements and can add a sense of grace and sophistication. The shape of your nails will partly influence their length and how best to polish and decorate them. For nails that are narrow at the cuticle and wider at the tip such as fan or square shaped nails, leave a strip of nail unpolished at the side and this will give the illusion of length and a more regular shape. You can always have nail extensions applied and this will then widen the choice of nail art literally available at your fingertips.

Nail polish

A good nail polish is one that is easy to apply, coats the nail and provides a tough protective surface that is resistant to chipping. The difference between a poor nail polish and a good one is not necessarily the price. A good polish will have a consistent texture and colour will remain true when it is applied. There are a number of different nail polishes, such as metallic copper, steel, or gold finishes. Others will glow in the dark or glitter attractively in one or more colours. Try them all to see which you like the best.

Treat your hands to a weekly massage and moisturise daily, take care that your hands and nails are protected from detergents by wearing rubber gloves. Look after your hands and nails as beautiful hands complete every look.

On the prowl

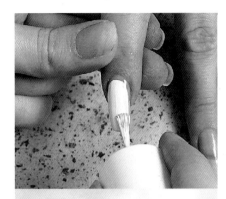

1 Apply a base coat and two coats of white nail polish to all nails.

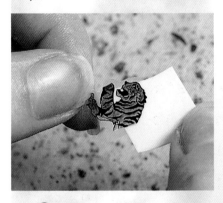

2 Dampen the back of the first transfer (the tiger's head) and remove the transfer, as shown.

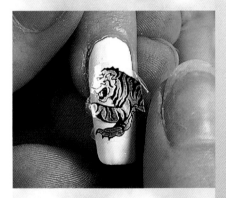

3 Position the transfer in the centre of the middle finger nail.

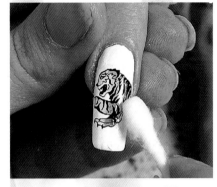

4 Smooth the transfer with a damp cotton bud to remove air bubbles and creases and to seal the edges.

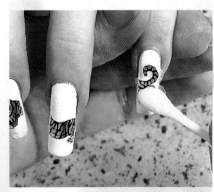

5 Follow the same steps to position the tiger's body on the ring finger, it's tail on the little finger, and front paw on the pointing finger. Finish with two coats of clear nail polish.

The image of the sleek, prowling tiger is spread over four wet-release transfers, so before starting, arrange the pieces in the correct order.

You *will* need
- base coat
- white nail polish
- sheet of wet-release
- tiger transfers
- scissors
- cotton buds
- container of water
- clear nail polish

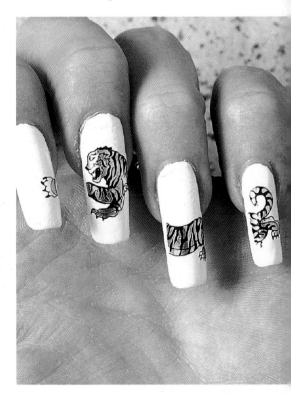

Marbling

Unless you are using a nail polish colour that contrasts dramatically with the nail paint colours, the best marbling effect is achieved over a clear base coat. To prevent paint colours running into one another, apply tiny amounts of each colour onto a palette, and wipe the marbling tool clean when changing colours.

You will need
- clear base coat
- yellow, red, and neon blue acrylic nail paint
- paint palette or similar
- marbling tool
- paper towel
- clear nail polish

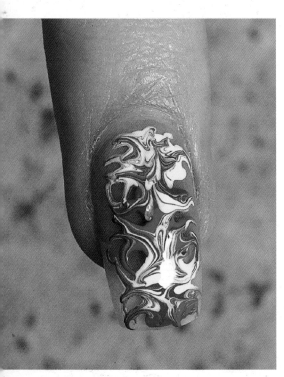

1 Apply a clear base coat. Use the larger round end of the marbling tool to drop blobs of yellow and red down the middle of the nail.

2 Wipe the marbling tool, then add blobs of neon blue to the nail. Don't worry if the colours start to blend on the nail.

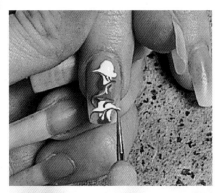

3 Wipe the marbling tool and use quick 'comma' stokes to swirl the colours and blend together.

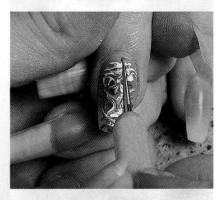

4 Continue marbling until the nail is covered. When dry apply two coats of clear nail polish.

Tip
- Do not go overboard with the marbling tool and 'swirl' the paints to a uniform muddy-brown colour. Try to keep the colours distinct.

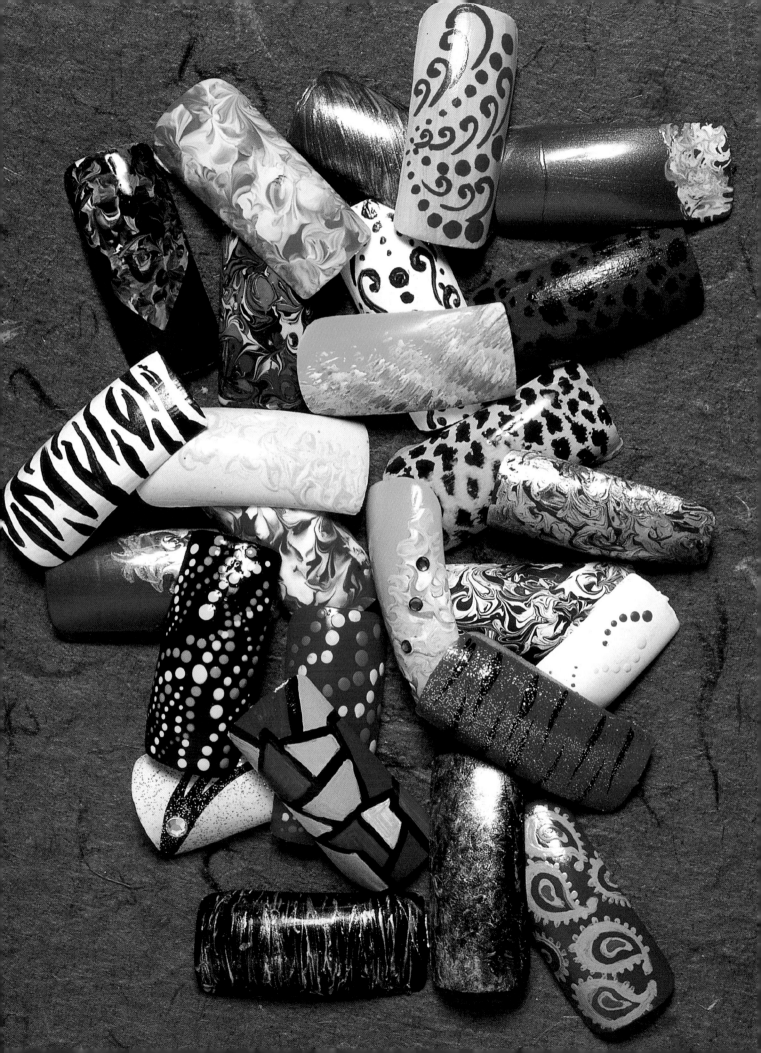

Index

Acknowledgments

Josephine Pierre at Warpaint Ltd.

Make-up and accessory suppliers:
M.A.C.
Claire's Accessories
L'Oreal
Lancome
Christian Dior
Prescriptives
Paul Mitchell

Models
Bianca Knight
Chantelle King
Daniella Boon
Elizabeth Offredi
Hannah Douch
Holly Futcher
Johanna Sullivan
Katy Tucker
Kimberley Glover
Leanne Ball
Lisa Moore
Lorraine Sweetman
Melissa Stow
Nancy Normile
Nancy Roberts
Natalie Henson
Nicole Egmund-Hoeg
Patricia Benford
Rebecca Lee
Simone Measures
Susan Benford

Help during the shoot
Angela from The London Esthetique